ELECTRONICS

FOR

SHUTTERBUGS

Acknowledgments

We'd like to express our gratitude to the many individuals and component manufacturers without whose assistance and counsel this book would have been impossible. In particular, we wish to credit William H. Sahm, of General Electric Semiconductor Products Department; R. C. Park of RCA Electronic Components, and International Rectifier Semiconductor Division. A special debt is owed Clairex Electronics, a Division of Clairex Corporation, for the material which formed the basis of the Appendix.

Robert M. Brown
Mark Olsen

No. 679
$8.95

ELECTRONICS FOR SHUTTERBUGS

By Robert M. Brown & Mark Olsen

TAB BOOKS
Blue Ridge Summit, Pa. 17214

FIRST EDITION

FIRST PRINTING—JUNE 1974

Copyright ©1974 by TAB BOOKS

Printed in the United States
of America

Hardbound Edition: International Standard Book No. 0-8306-4679-5

Paperbound Edition: International Standard Book No. 0-8306-3679-X

Library of Congress Card Number: 74-75217

Contents

Foreword

In almost any hobbying field, a basic knowledge of electronics will prove rewarding, for there are almost always special circuits that can be built up easily and inexpensively. But with photography the rewards are even greater, for there never seems to be an end to the little electronic aids the shutterbug can whip up with a soldering iron, a pair of wirecutters, and a handful of transistors, resistors, and capacitors.

But the fact of the matter is, you really don't have to know basic electronics to build a circuit that works. It helps, to be sure, but it isn't really a prerequisite.

The authors—Bob Brown and Mark Olsen—have taken pains to gear this book to a composite audience of two types of hobbyist: the shutterbug and the tinkerer. The first section of this book is designed to acquaint amateur photographers with the basics of electronic construction. You'll find no blue-sky theory here no matter how close you look. The material is stripped down to the barest essentials—what you have to know to build electronic circuits that work right the first time. The second section, addressed to the solder jockey, covers basic darkroom techniques and offers suggestions for design of effective photo-processing and working quarters. By the end of the second section, all readers should be on an equal footing.

The balance of the book is a compendium of useful circuits—divided into three categories: easy, intermediate, and advanced circuits. Probably, the newcomer to electronics hobbying will be well advised to begin modestly by constructing a circuit selected from the easy offerings. In practicality, though, you're sure to find the easy projects every bit as valuable as the interesting circuits that follow. And regardless of circuit complexity, your construction efforts are going to be well rewarded. That's a promise!

The Publishers

The Elements of Electronic Construction

For the person whose specialty is photography, and who may have little or no experience in the field of electronics, discussions of a few of the elements of constructing an electronic device are in order. A few basic tools, the most frequently encountered components, chassis development, soldering techniques, and safety precautions are taken up in the following pages.

TOOLS

There are a few basic tools that may be considered common to all electronic construction projects. These consist of long-nose and cutting pliers, two or three screwdrivers, and a soldering device—plus solder and wire. Often, more complex projects will require such "hardware" items as drills and bits, files, reamers, etc. To help you select the right tools, elementary descriptions of their requirements are given here.

Soldering Iron

The soldering of transistor circuit components is best accomplished with a pencil-type soldering iron in the 20- to 30-watt range, such as the unit shown in Fig. 1-1. This type of iron will give enough heat for light, delicate work without overheating the components.

Solder

Always use rosin-core or "electronic" solder. Acid-core types can do more harm than good in an electronics project, because residual acid will continue to "clean" wire connections long after the soldering operation has been completed. The result is unwanted "etching" that can cause future failure.

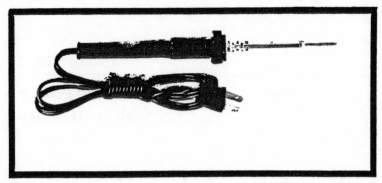

Fig. 1-1. A low-wattage soldering iron or "pencil" is a must for serious electronic construction.

Hookup Wire

Insulated (plastic-covered) solid copper hookup wire of 20-22 gage (AWG) is a must for nearly all connections between components. Where 117V primary power is used, heavy-duty 18-gage line cord is recommended.

Long-Nose Pliers

A 5 in. pair of long-nose pliers (Fig. 1-2) is useful both for handling small components and for twisting and looping hookup leads. You'll find this tool indispensible.

Diagonal Cutters

Trimming and cutting can be a problem without this aid. Like long-nose pliers, you just can't get by without "dikes."

Screwdrivers

Both medium- and small-blade screwdrivers will be handy for whatever the other tools don't do. Your local electronics parts distributor will show you "driver kits" that are extremely handy; these contain miniature screwdrivers as well as popular-sized "nutdrivers," or light box wrenches with screwdriver-type handles.

Drill

A small hand drill, preferably the quarter-inch electric type, is valuable for drilling small holes and even creating

starter holes for larger ones when doing work on metallic chassis or enclosures. You probably won't need more than a handful of bits, so buy the best here—to avoid premature dulling and annoying breakage.

Files

A set of three files is recommended for the complete hobbyist—a quarter-inch (diameter) rat-tail, a half-round "semi" file for smoothing curved edges, and a small tapered "square shank" type for squaring metal corners. In general, select the **fine** cuts rather than **coarse**.

Miscellaneous "Extras"

Other tools for chassis work, not **musts** but extremely useful, include a nibbling tool for cutting large holes (Fig. 1-2D) and a tapered hand reamer (Fig. 1-2E) for enlarging small round holes. If you intend to get involved in chassis

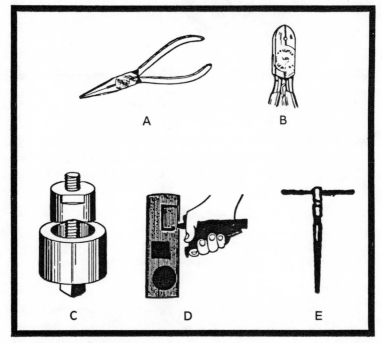

Fig. 1-1. A low-wattage soldering iron or "pencil" is a must for serious electronic construction.

11

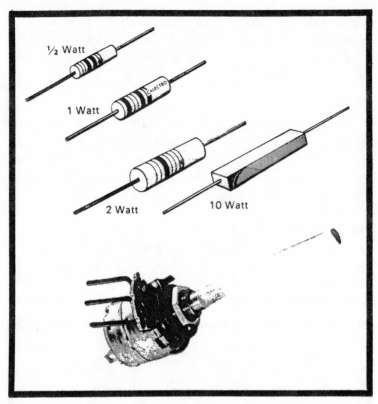

Fig. 1-3. Some related components. Above, various resistors; below, a potentiometer (actually, a variable resistance).

construction to any degree, you'll also find "knockout" punches extremely handy; they make exceptionally clean holes in metal chassis and are incomparable for professional-looking metalwork.

ELECTRONIC COMPONENTS

Listed below are the parts that you will come across most often in your work with the projects in this book:

Resistors

A resistor, as the name denotes, offers resistance to the flow of electric current. Electronic circuits, as a rule, incorporate many resistors to reduce or limit voltage, to isolate or filter circuits, to act as a **load** for tubes or transistors, etc.

12

The value of a resistor is shown in ohms, kilohms (thousands of ohms), or megohms (millions of ohms). A kilohm is 1000 ohms; a megohm is one million ohms. A 47-kilohm resistor is conventionally abbreviated 47K; a 10-megohm resistor would be abbreviated 10M. A resistor (Fig. 1-3, top) has no polarity and can be wired in a circuit either way.

The wattage rating of a resistor refers to the maximum amount of power the component can dissipate as heat without itself being burned to destruction. Space permitting, a higher wattage unit may always be used as a replacement for a lower wattage type. Resistors are generally coded with stripes that indicate their ohmage value, as shown in Fig. 1-4.

Potentiometers

A potentiometer is a variable resistor. The current and voltage applied to a potentiometer must be kept within

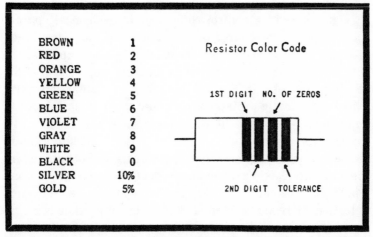

Fig. 1-4. A color code is used by most carbon-type resistors to indicate value, each particular color designating a number as shown in the chart. Standard components have three bands to show value. As shown in the diagram, the first band denotes the first digit of the resistance value, and the next band denotes the second digit. The number of zeros following the first two digits is given by the color of the third band. Example: a sequence of brown-black-red means "1" for the first digit, "0" for the second digit, and "2" for the number of zeros to be added—giving the resistor a value of 1000 ohms. Similarly, green-blue-black gives 56 ohms. Tolerance is often indicated by a fourth color band. A silver tolerance band means that the actual value of the resistor is within 10 percent of the coded value; a gold band in the fourth position means 5 percent tolerance. When there is no fourth band, tolerance is 20 percent.

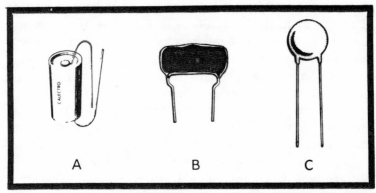

Fig. 1-5. Capacitors take a variety of forms. Those pictured include (A) electrolytic tubular, (B) Mylar paper, and a (C) ceramic disc capacitor.

specified limits; otherwise, the device will heat up or burn out. A potentiometer is wired to both ends of the resistor and to the movable contact arm, which slides internally along a resistive element.

The **taper** of a control refers not to a physical characteristic, but to the degree of resistance variation for a given shaft rotation. **Linear** tapers are used for general application; that is, the resistance variation is directly proportional to the rotation of the shaft. For volume controls, though, an **audio** taper is generally preferred. An audio taper is calculated to compensate for the nonlinear response of the human ear. Potentiometers are widely used for volume, sensitivity, and tone controls, to vary and divide voltages, etc. Potentiometers may use a resistive element of deposited carbon, a long winding of resistance wire, or any of several other schemes. Selection of resistive elements may be important in some areas involving radio usage.

Capacitors

Capacitors are used in practically all electronic circuits, most often to store energy. Other uses include blocking direct current while letting alternating current pass, isolating amplifier stages, tuning rf circuits, starting motors, filtering some frequencies from others, etc. As shown in Fig. 1-5, they come in many different types and names—electrolytic, ceramic, mica, disc, Mylar, tubular...each with its value

14

stamped or color-coded on the outside in microfarads (uF) or picofarads (pF). A microfarad is a millionth of a farad; a picofarad is one millionth of a microfarad. You can easily convert from one unit to the other by simply moving a decimal point six places to the left or right. A 0.001 uF capacitor, for example, is the same as a 1000 pF capacitor; the decimal has been moved six places to the right. All capacitors used in the projects in this book have values in the microfarad range. If you have trouble reading a capacitor's code, you can refer back to Fig. 1-6.

A capacitor's **working voltage** (WVDC) is the maximum voltage that can be applied to a given capacitor, so capacitors can usually be used to replace any capacitor of the same or lower value. A 450-volt (450V) capacitor, for instance, can replace any unit rated up to 450V. The only exception is the

Color	Digits of Capacitance (pf) 1st Significant Figure	2nd Significant Figure	Multiplier	Tolerance %	DC Working Voltage
Black	0	0	1	±20	—
Brown	1	1	10	—	100
Red	2	2	100	—	200
Orange	3	3	1,000	±30	300
Yellow	4	4	10,000	—	400
Green	5	5	—	—	500
Blue	6	6	—	—	600
Violet	7	7	—	—	700
Gray	8	8	—	—	800
White	9	9	—	—	900
Gold	—	—	—	—	1,000
Silver	—	—	—	±10	—

TUBULAR PAPER

Coding for tubular paper capacitors.

Fig. 1-6. Capacitors are often coded, too. The code shown here applies to molded tubular types.

electrolytic capacitor. This type shouldn't be used at voltages above or very far below its rating. A 25V electrolytic capacitor, for instance, is all right to substitute for any unit specified at from 10 to 25V. But a 150V electrolytic should be avoided in this situation. Though no damage may result, the effective capacitance might be different from what you might require in the circuit. In other words, the value of an electrolytic tends to be voltage-dependent, and the value is based on use at the specified working-voltage rating.

Always observe polarity for electrolytics; that is, the lead marked + should always be connected to a higher-polarity voltage than the unmarked (negative) lead. Schematics take this into account and show a plus symbol adjacent to the electrolytic symbol.

Diodes and Rectifiers

These devices "cut out" one half of an alternating (ac) signal, converting it to pulsating direct current (dc). The schematic symbol reveals polarity—a crucial item to watch for with this component. A diode is nothing more than a valve; it lets current pass through in one direction only. If the current reverses, the diode blocks flow.

Transformers

Power ratings are the result of how much iron a transformer has in its core, and of the wire sizes used in its windings. Though higher rated transformers are naturally larger, most of the types required for the projects in this book are not bulky. Power and filament transformers deliver their specified output voltage only at their rated loads. If lightly loaded, their output voltages will be higher than specified. If overloaded, output will drop and the transformer may overheat.

Impedance matching is a must if you want maximum circuit efficiency in an audio transformer (Fig. 1-7). Most circuits will tolerate minor mismatching (up to around 10 percent) without noticeable effect.

Electronic Industrial Association standard colors make it easy to identify the lead wires of American-made transformers, as shown in Fig. 1-7.

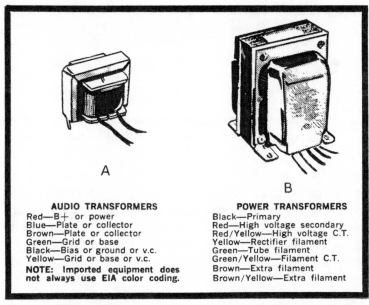

AUDIO TRANSFORMERS
Red—B+ or power
Blue—Plate or collector
Brown—Plate or collector
Green—Grid or base
Black—Bias or ground or v.c.
Yellow—Grid or base or v.c.
NOTE: Imported equipment does not always use EIA color coding.

POWER TRANSFORMERS
Black—Primary
Red—High voltage secondary
Red/Yellow—High voltage C.T.
Yellow—Rectifier filament
Green—Tube filament
Green/Yellow—Filament C.T.
Brown—Extra filament
Brown/Yellow—Extra filament

Fig. 1-7. Transformers may be tiny or huge; miniature audio transformer at right is a standard power transformer. Conventional color coding of transformer leads is explained below each sketch.

Small-Signal Transistors

These now familiar components are generally used to amplify minute signals. This is the type encountered most frequently in this book. Other types—the power transistor, for instance—are capable of amplifying much larger signals.

Switches

Abbreviations for switches describe the number of contacts (poles) a switch has, as well as its switching mode. An SPST switch, for example, is a single-pole, single-throw type. This means that it has one movable and one fixed contact. The most used switch abbreviations are shown in Fig. 1-8.

Momentary-contact switches operate only while they are being pressed. If a momentary-contact switch is a double-throw type, one contact is normally open and the other normally closed. You may usually substitute a more complex switch for a simpler type, if you like. An SPDT switch can replace an SPST, for instance, by simply ignoring one contact position.

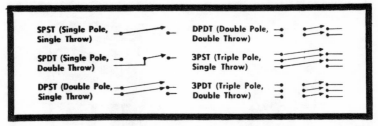

Fig. 1-8. Conventional diagrams and abbreviations of common switch types.

Connectors

All projects should be built with the connector types recommended in the parts lists. Power connectors (ac plugs and sockets) are specifically designed to safely handle high-voltage, high-current levels. Test jacks and plugs, on the other hand, are generally used for audio or low-level signal applications.

Relays

Current passing through a coil can influence a spring-action arm in the near vicinity. This is the principle behind the relay, used in numerous projects in this book. Notation for relay contacts are the same as that of switches. One of the most important factors in selecting a relay is the coil's impedance rating in ohms. Substitutions are in many cases acceptable, as long as this factor is kept in mind.

Other relay parameters of importance are: current-handling ability of contacts, pull-in voltage (minimum amount of voltage applied to coil that will cause pull-in of the armature and, thus, switching), and coil current. In some cases it is also important to know the dropout voltage. Circuit capacitance and other factors may cause a residual voltage to appear on a relay's coil even after coil voltage is ostensibly removed; thus, it may be important to know in advance how much residual voltage a relay can tolerate without being hung up in the actuated position.

Boards and Chassis

Most circuits, surprisingly enough, can be mounted on almost any type of base, including many materials you have

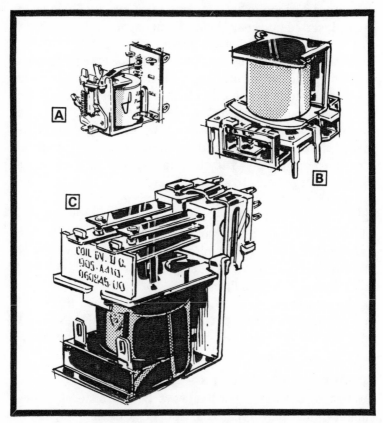

Fig. 1-9. Typical relays for electronic switching: (A) subminiature type; (B) small "sensitive" relay, and (C) power switching type.

around the house. Plastic boxes, cigar boxes, aluminum "miniboxes," pegboard pieces, and phenolic "perfboard" are just a sampling of the wide variety that is open to the enterprising experimenter.

Aluminum, perhaps the most popular material for hobbyists, is especially suitable for many of the projects in this book because of the stability and rugged protection it provides. It is much more workable than steel and can often serve as both cabinet and chassis. Also, a circuit constructed on perfboard is easily secured inside a suitable aluminum housing.

Perfboard is ideal for buildup of basic circuits because it is laid out with precisely sized holes in neat but close rows over

its surface. Special clips (binding posts) are available which can be inserted into board holes. Components and leads fasten directly to these termination points.

While obtaining aluminum sheet or chassis should pose no problems, hole cutting is a major consideration. This is where some of the tools previously mentioned come in handy. For small holes, an electric drill is recommended. For a larger hole, mark it with a pencil and drill a series of small holes spaced close enough to make the hole easy to punch out when it is outlined completely. The nibbling tool will cut a variety of shapes in large holes to accommodate meters, switches, etc.

Small round holes are conveniently made larger with a hand reamer. A small drilled hole can be readily enlarged with simply a reamer twisting action. Remove any burrs with a rat-tail file. Chassis holes for accepting screws may be made directly with a drill bit. A supply of short 6-32 screws (and nuts) should be all you'll need.

Lay parts out on chassis before making the holes; this brings attention to unsuspected obstructions and significantly adds to the professional appearance of your completed project.

SOLDERING TECHNIQUES

Improper soldering will always be the bane of project builders and home repairists. Proper soldering will aid in producing a fine piece of equipment; thoughtless haste will be a tremendous help in creating an expensive garbage heap of electrical components. The right amount of heat and the right amount of solder will give you a good joint; and only with electrically sound joints can a circuit operate properly. A little time spent learning correct soldering methods will save time in the long run looking for elusive loose joints. It is a great deal more than dropping a blob of solder on two wires!

In addition to soldering iron and solder, you should have a small metal cleaning brush, sandpaper, and a "soldering aid" —a small forked metal rod outfitted with a wooden or plastic handle. Coating the iron's hot tip with solder (called tinning) helps prevent oxidation, greatly facilitating the soldering operation. Taking this step will prolong the life of the tip. Wipe excess solder off the tip with a damp cloth.

Before soldering a joint, the terminal and wires should be freed of accumulated grease and crust with a brush and sandpaper. The joint should be firm enough to remain stable without the solder; wrapping the wires through the terminal at least two times and clamping them firmly into place will assure this stability. The long-nose pliers come in handy here!

When applying solder to the joint, this important sequence should be followed: Heat the joint **first**. Then apply solder—to the joint, **not the iron**! If this procedure is followed, you will avoid a **cold** joint, where the solder has not actually flowed over the elements and fused them together. A good connection is shiny and ribbed. After trying a few, these are easily identified. Only a little solder is ever required. Practice first.

Resistors, transistors, and diodes are extremely sensitive to heat; for this reason, care must be taken in soldering their leads. Even a relatively small amount of heat can quickly destroy a transistor. Use a **heatsink**—a metal object attached to the lead between the transistor and the soldering gun to draw off excess heat. An alligator clip works quite well. Sockets on which all soldering can be done before the transistor is installed are convenient and a sure-fire protection against heat damage to the transistor. Beware of filling the socket holes up with solder, however. Another idea, if sockets aren't handy, is to use long-nose pliers as a heatsink; a rubber band will hold them closed. Many experimenters use "hemostats." Available at medical supply outlets, the hemostat is a scaled down version of long-nose pliers with a scissor-like handgrip. The hemostat's delicate jaws may be clamped shut, which makes them "naturals" for temporary heatsink applications.

TROUBLESHOOTING

Troubleshooting is best done during construction. Check each connection at least twice for errors in assembly. If difficulty is experienced after the circuit is complete, have someone else check the connections. An outsider can often find mistakes overlooked by the project builder.

Power polarity—positive to positive, etc.—is extremely critical. Also check for the presence of power! Check the

polarity of parts that can be installed in only one direction—electrolytic capacitors, diodes, etc. Switching them can lead to a burnout or incorrect circuit operation.

Recheck solder joints. This can be accomplished by holding each wire and moving it slightly while the circuit is on. Resolder the joint if it is bad.

Short circuits are a frequent cause of trouble. No bare conductors in the circuit should come into contact with any other lead. Heating up, parts smoking, and fuse blowing are obvious signs of this type of trouble.

When you suspect a short circuit disconnect the power source immediately if you want to salvage your valuable electronic components.

SAFETY

Electricity can be put to exciting hobby uses, but it can also harm—and even kill—if it is handled carelessly. Rules of conduct when working with electrical equipment are quite simple and to the point:

1. Avoid shock. Never touch live component parts or wiring with any part of your body while the circuit is on. Use the common-sense radio-TV technician's practice of putting one hand in the pocket at all times when making screwdriver adjustments. This way, the chance of a shock passing through the body is minimized.

2. Know well the operational circuits of the electronic equipment being built, tested, or used. Know what voltages to expect at different points in the circuit.

3. Avoid "personal" grounds. A wooden platform or rubber mat will keep your feet (which are damper than you might think) off the basement's cement floor.

4. Plan all your work carefully. And never work in a messy or disorganized area; to do so is to invite catastrophe!

5. Turn a circuit off and remove the power plug from the wall outlet before replacing parts or tinkering with its internal circuitry.

6. Power lines are extremely dangerous—being just the right frequency to turn your heart off permanently. Exercise

extreme caution with ac equipment containing no isolation transformer—such as ac-dc radios and television sets.

7. Never trust an electrolytic or filter capacitor. Discharge each one a couple of times if you are working with a disconnected circuit that has been in operation within the last 24 hours. Putting a **bleeder** resistor (high wattage, high ohmic rating) across all filter capacitors is a good idea.

8. Never touch large choke coils until you're certain that power is off and electrolytic capacitors have been discharged. They can deliver a real jolt to the unwary.

9. Quit when tired.

Section 2

Darkroom Considerations

The photographer's workshop is the darkroom. Since the materials with which the photographer works are sensitive to light, most of the workshop operation must be carried on in darkness or under light of very carefully controlled color and brightness.

The equipment and facilities should be properly arranged for a convenient and effective flow of work, and since many of the operations are performed in very low light or in total darkness, the layout should be carefully planned.

Safelights should be arranged to give as much light as the sensitivity of the materials being handled will allow; and because some of the operations can be carried on under normal light, the lighting provided for these should be as bright as possible.

The size, arrangement, and equipment of the darkroom will vary with each photographer. Space and equipment needed depends on the kinds of work to be done. For all darkroom photo work, however, the sequence is about the same; so the darkrooms described here are examples of efficient and convenient arrangement for any shutterbug.

LOCATION

This is determined by space available but should (1) be convenient, (2) have running water available, (3) be dry, and (4) have uniform temperature (preferably between 60 and 70°F). For most homes, a dry basement works out to provide most of these conditions, and a basement floor can best stand up under the occasional spill of water or solutions. An added convenience would be a floor drain for easy cleanup at any time.

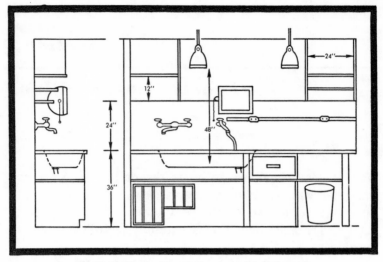

Fig. 2-1. Elementary but complete darkroom.

HOME DARKROOM

A very good darkroom layout for home use is shown in Fig. 2-1. This arrangement calls for 10 ft of wall space; it needs a total space of 5 by 10 ft, and provides for a convenient flow of work in the processing of roll, cartridge, or sheet film, and for making contact or enlarged prints up to 11 by 14 in. One person can work very efficiently, and even two people can work together in this darkroom without getting in each other's way.

The darkroom unit consists mainly of a 26-in.-wide work surface that is a full 10 ft in length. A stainless steel or plastic sink is mounted flush with the surface and 1 ft from the left end. This provides some working space at one end and still leaves 6 ft or so of working surface on the other side for printer, enlarger, trimming board, or print dryer. About 24 in. above the bench is a shelf 9 in. deep with a 2 ft (wide) open shelf arrangement at each end. The central part of the bottom shelf is meant for bottles of solution; the space at the left is for extra chemicals. Printing and enlarging paper may be kept on the right side. The shelves below the bench are convenient for storing trays and other equipment.

Two safelight lamps are hung from above at a height no closer than 4 ft to the working level. One lamp provides

illumination for the enlarging easel and the trimming board, the other for developing trays in the sink. A third safelight mounted on a trunnion bracket over the sink serves for illuminating negatives or prints. The continuous outlet strip on the back wall, high enough to be away from moisture, is ideal for plugging in all electrical equipment on the counter.

The plumbing fixtures consist of a hot and cold mixing faucet and an extra cold water faucet with a hose for servicing the wash tray.

Accessories such as graduates, thermometers, and tongs are kept over the sink. This entire arrangement provides for a smooth flow of work. When enlargements are made, paper is taken from a storage shelf, trimmed to size if necessary on the trimming board, placed in the enlarging easel, exposed, and passed on to the developer. The developing, rinsing, and fixing trays can be placed on a rack over the sink, or distributed on both sides of the sink, allowing for the prints to be finally washed in the sink itself.

Refinements of this elementary arrangement will include a stainless steel sink large enough to hold the processing trays in a controlled-temperature water bath, an overflow pipe to keep the sink from running over, a separate section of the sink to be used for supplying water at a constant temperature, and a lightproof drawer and cabinet installed under the enlarger to hold opened packages of paper so that they will not have to be wrapped up whenever the white inspection light is turned on.

DARKROOM WIRING CONSIDERATIONS

The processing of film and prints requires large amounts of water and chemicals, and the darkroom becomes a very humid place to work. In the presence of this inevitable dampness, the 120V ac power which is used for illumination, safelights, and equipment operation represents a serious electric shock hazard for the photographer in his own darkroom.

Sometimes a man can touch an exposed wire and receive only a shock, even when his hands are dry and he is standing on a dry floor. However, it takes less than 300 milliamperes of current to kill a man, and this much current can easily flow

through the body at a potential of only 120V when the skin is wet and when the body is grounded. This latter situation can occur very easily if you have one hand in the water in a grounded wash tank and reach for a defective pull chain switch with the other hand.

All switches on sockets should be eliminated from darkroom and other wet areas. Lights should be controlled from wall switches in grounded metal boxes.

As far as possible, all lighting fixtures should be permanently attached, and all darkroom wiring should be installed in thin-wall conduit with adequately grounded outlet boxes.

All power receptacles arranged on the walls as convenience outlets should be located a reasonably safe distance from and preferably above any splashing source of water, and should always be of the "U" grounded type to accept the three-prong plug commonly used with portable electric tools.

Electric Short Circuit

A short circuit may occur as a result of any of these conditions:

- Mistake in wiring.
- Joining two main wires from the electrical source.
- Bare wires coming together.
- Bare wires coming in contact with a ground such as a water or gas pipe, a radiator, or an electrical conduit.
- Bare wires coming in contact with the ungrounded frame of a piece of photographic equipment, or the ungrounded shell of a light fixture hanging from a cord, and then finding a path to ground through the hands and feet of a home photographer.

Short circuits will usually be accompanied with some local fireworks and the blowing of a fuse or the tripping of a circuit breaker. If flammable materials are nearby, a fire is likely to start.

Extension cords and their contacts are also responsible for many problems. It is better to avoid use of extension cords

in darkrooms. However, if it becomes necessary to use one, it is strongly recommended that you use a 16-3 (rubber-covered) flexible cable with a good third-wire ground at the electrical source. It never hurts to consult an electrician on the proper manner for wiring a plug—you will be surprised at what you can learn from a pro.

Equipment Loads

The power equipment and electrical loads for a typical advanced amateur's darkroom can be fairly closely estimated. While there are sure to be variations, you can use this table as a guide:

- Printer—150 to 300 watts—3 amperes
- Enlarger—200 to 300 watts—3 amperes
- Washer—150 watts—1.5 amperes
- Print dryer—1000 to 2000 watts—10 to 20 amperes
- Lighting (total)—150 to 300 watts—3 amperes

A reasonable approach to the wiring of a darkroom would be to run a line from your house's main fuse or circuit breaker box, which will feed a two-circuit breaker box installed at the darkroom location. It is desirable to separate the wall-receptacle **power circuit** (20 amperes) from the lighting circuit (15 amperes). There's a good reason for this "splitting": When you have a problem with a power-consuming appliance that is severe enough to trip a breaker, you may not mind losing power temporarily, but you certainly do need your lights so you can see to repair the fault!

The electrical code in your area probably requires that all house wiring be run inside thin-wall conduit in such a manner that the conduit forms a good electrical ground circuit for your wiring system. It is practical to do your job with the conduit and outlet boxes on the **surface** of the walls in your darkroom so that you can make changes after a year or two without tearing up your walls.

The best you can do the first time around is to install about twice as many outlets as you think you will need. Hopefully this will keep you from outgrowing your electrical wiring service before too long. The natural trend—as the amateur photographer grows with his hobby—is to add

controls to the process to make the job easier and to produce more pleasing results; and interestingly enough, the need to "plug it in" is apt to grow, not decrease.

Circuit Breaker

The circuit breaker is a protective device, a spring-loaded switch which is tripped by a current overload, thus shutting off the current. The tripping element may be a magnetic coil which develops enough pull to trip the switch at its rated setting, or it may be a thermal element which heats up and trips the switch. A circuit breaker is built so that if you try to reset it with the overload still on the line, it will not go to the on position and close the circuit. Once the overload is removed, a flick of the handle resets the switch and the power is on again.

Grounding

Repeated references to **ground, continuous ground,** and **good electrical ground** have been made with the assumption that all readers know the importance of this portion of a wiring circuit. For anyone who may **not** have learned the basic safety reasons for having a good ground circuit available in all electrical wiring circuits, the following reasons will be doubly important.

When electricity is transmitted from a power source (fuse or breaker box, power receptacle, etc.), it is carried by an electrical conductor to a point where it can do a job such as light a light, run a motor, or power a heater. The wire is at a higher potential, or voltage, than what is around it; and to protect and preserve the power available in the wire, it must be insulated—usually with rubber or plastic. Once the electrical energy travels through the light or heater or other load, it must be conveyed **back to the electrical source** via another conductor. All 120V electrical jobs to be done in the small darkroom can be accomplished with two wires, insulated from each other and from the grounded conduit in which they are run from the power source to the job. The grounded conduit serves as a protective sheath. If any action causes the electrical conductor to come into contact with the grounded conduit (a short circuit) the current flow will be **heavy** and immediate, and will cause the circuit breaker to trip. With the overload, the tripped breaker allows no more voltage to be

delivered to the load. So the short circuit presents no fire hazard or shock hazard to personnel.

If any of the joints in the ground circuit are poor (high resistance connections), the current cannot go back to the ground source in great enough volume to trip the breaker, and the "partial" ground exists as a potential source of heat **and** shock hazard where people can touch the outside of the conduit, receptacle, or frame of the appliance. If the **frame** has a high potential because of an internal ground that could not trip the breaker because of a faulty ground circuit or no ground circuit at all, then the frame itself becomes a lethal shock hazard. If a person who is in contact with a good ground, such as hand in water, or a water faucet, touches such a "hot" frame, he may likely be electrocuted. Such is the danger of ungrounded circuits, and conversely, such is the very great safety importance of a good and complete ground circuit at all times.

Darkroom Wiring Arrangements

For the purpose of illustrating a wiring distribution requirement, a typical darkroom is shown in Fig. 2-2. The alphabetic coding on the drawing represents these elements:

A — switch at entrance

B — switch in series with A

C — white light which can only be lit when A and B are closed (when B is open nobody can enter the room and turn on white light C by closing A)

D, E, F — safelight controlled by 3 switches directly above them

G — Red hanging safelight with wall switch

H, J, — indirect red and green safelights controlled by two wall switches near entrance

K — double convenience wall outlet

L — wall switch

This illustrated darkroom affords ample room for two or three people to work at the same time, provided their lighting requirements are similar. Note the detail of the maze entrance, which affords good ventilation and easy passage for people in and out with no doors to open.

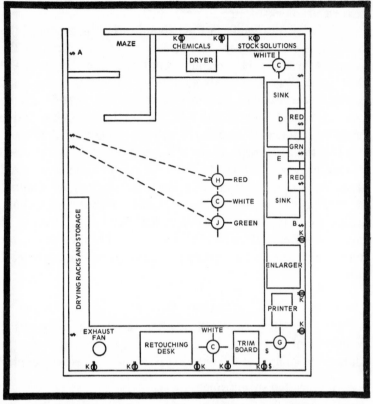

Fig. 2-2. Complete darkroom with maze entrance, showing wiring arrangements.

Where space is more limited, a light-tight door opening may be used in place of the maze, with the same two switches in series to control the white ceiling light for the safety of the photosensitive materials.

Figure 2-3 shows a slightly smaller version of a darkroom with a light-tight door for an entrance in place of a maze entrance. Floor space required is less, but the problem of accidental intrusion or light-tight security at critical times must be considered. Communications can be handled with an intercom system, to keep you from having to shout through a well sealed door.

Security can be covered by installing a small red light outside the door. This lamp goes on whenever the safelights inside are turned on, to serve as a warning to visitors that the

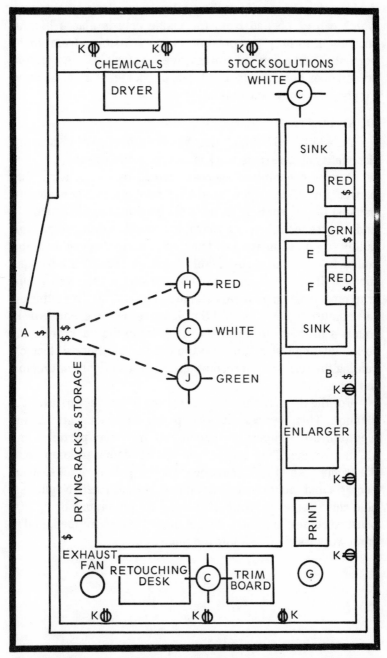

Fig. 2-3. Complete darkroom with lightproof door, showing wiring arrangements.

darkroom is in use. Installing a latch-type lock on the door which can be opened from the inside only is also a helpful security measure (to prevent unwary visitors from inadvertently exposing photosensitive materials). A simple screen-door hook can be used, too, of course. It's not so safe, maybe, but very economical!

DUST CONTROL

An additional "extra" that has the potential of improving the quality of darkroom work is complete dust control.

A very economical approach would be to use a surplus blower fan of the type used in forced-air furnaces as an exhaust fan. If running at normal speed moves too much air and creates too much of a roar it is a simple matter to change pulley size and run at some fraction of normal speed until the sound is down to a reasonable level. A regular fiber-glass furnace filter in a frame on the intake side of the room would trap most of the dust from outside sources. A similar filter on the exhaust side can control the cleanness of the exhaust air if this is a problem in the space adjacent to the darkroom. Internal dust can be reduced in the case of a concrete floor by sealing the floor with a recommended type of floor coating for darkrooms.

For the ultimate in dust control install an electrostatic air cleaner. This device will sweep the darkroom air clean, electronically trapping virtually all airborne particles including smoke. This type of air cleaner helps to keep your darkroom free of dust, chemical fumes, pollen, smoke, even bacteria and mold spores—down to submicron size. Negatives held close to the unit's air-intake and simply tapped or lightly brushed come clean fast—dust is sucked in and trapped, and it can't work its way back into the room again.

Section 3

Easy Projects

SLAVE FLASH UNIT

Adequate lighting for home photo sessions can usually be found with the single camera-attached strobe or flashgun; but occasionally you'll need a supplemental "fill-in" flash to cover areas that would otherwise be in shadow. Closeups especially often require the extra light to avoid alternately "burnt" and "underexposed" areas. Many photographers, both professional and amateur, make use of one or several slave units that are synchronized to the camera shutter with either a direct electrical connection or with a light-sensitive triggering device that reacts at the speed of light. It once was done with long, dangling cords—turning a studio into a place reminiscent of the vine-strewn jungle—but these days it is accomplished by means of a very simple light-operated trigger circuit.

The circuit can be used with either type of flash—making it good for this transitional period between gun and strobe. It is assembled with a handful of components and a modest two hours of workshop time. The effort and money will be more than repaid by the extraordinary utility of the trigger and by its outstanding results (they'll glimmer right through your developing solutions).

HOW IT WORKS

The total slave flash unit is a combination of an accessory circuit and your flash attachment. If you can supply the flash, the circuit presented here will do the rest. Acting with the speed of light, it is every bit as reliable as commercially available units.

The circuit, shown in Fig. 3-1A, is essentially a light-activated electronic switch, but designed specifically for use in flash applications. The switching action is accomplished by

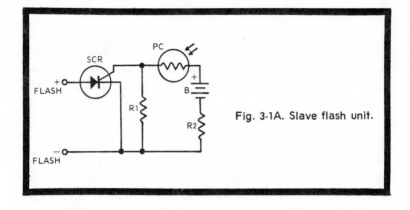

Fig. 3-1A. Slave flash unit.

the firing of a silicon controlled rectifier (SCR). Current for this switching and firing action is supplied by the battery through photoconductive cell (PC) and resistor R1.

Under normal conditions, very little light falls on the photocell. Its resistance is subsequently high and the electronic switch behaves like an open circuit. When it receives the intense light of the master flash, however, the resistance of the cell decreases dramatically, applying enough current to the gate of SCR1 to cause it to fire. This triggering action in turn triggers the external flash to which it is connected. In the event that a flash is fired in very close proximity to the photocell, resistor R2 acts as a safeguard to protect against too much gate current. Power for the slave flash itself, of course, comes from its own supply. All that the accessory circuit provides is an automatic switching action. Since the master flash is very brief, the conduction time of SCR is correspondingly short. As with the flash itself, the battery supply of the slave trigger is drained only momentarily.

CONSTRUCTION

Any type of container at all can be used for the assembly, as the parts layout is not critical and the number of components is few. A small rectangular box of about 2 by 3 in. will serve the purpose. A small piece of circuit board cut to size and fitted with small machine screws and nuts for solid mechanical component lead connections will simplify construction considerably.

The battery can be secured on the opposite side of the board from the other components. Use cable clamps to secure the silicon controlled rectifier and photocell at opposite ends of the insulated board, with the photocell extending beyond the end of the board and through a hole in the chassis, as shown in Fig. 3-1B. For layout convenience, the SCR and these two components should be located at opposite ends of the board. It is also a good idea to use "spaghetti" sleeving on the leads to prevent any electrical accidents in the rather tight situation that a small enclosure presents.

Battery clips for the other side of the board can be fashioned from brass strap that can be easily bent into shape.

After all the connections have been made, the flash itself must be brought into the circuit. This is done by cutting the connector off the camera end of the flash-unit connecting cord. Pass the lead through a small hole in the slave trigger's enclosure and connect it by soldering into the circuit as shown in the schematic.

Clipping the batteries into place completes the process. Although current drain is measured in microamperes when

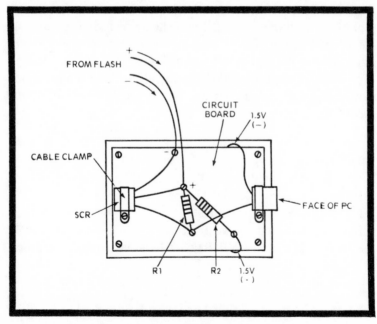

Fig. 3-1B. Wiring diagram for the slave flash unit.

the trigger is not operating, you may want to include a miniature SPST switch in the power lead for convenient on-off switching. Otherwise, unclipping the batteries when the unit is not in use is simple and easy.

USING IT

The sensitivity of the slave flash depends primarily on how far it is from the master flash. The slave trigger can be clamped to the same support that is used for the flash unit. With a cord of sufficient length, the trigger unit can be placed nearer the camera than the controlled flash needs to be. Increasing the value of resistor R1 will generally heighten the sensitivity of the slave trigger.

When everything is set up, the master flash and slave should fire simultaneously. If the slave setup does not fire, there are a number of things that can be done to determine what the problem might be: Check cable connections and battery polarity first. If everything is all right here, go to the photocell and SCR. The photocell can be disconnected and its resistance measured on an ohmmeter to read high and low light intensities. The values should be around 100 ohms when light falls on it and 10 megohms when covered. You can connect lead 2 of the SCR directly to the positive side of the battery to make the slave flash fire as a test. If the device doesn't fire, either the battery or SCR is defective. After the project is completed and tested, you will be the happy owner of a versatile slave flash accessory.

PARTS LIST

B — 1.5V penlight cell (size AA)
PC — Clairex CL904N photocell
R1 — 22K, ½ watt resistor
R2 — 47 ohms, ½ watt resistor
SCR — Motorola HEP R1221 silicon controlled rectifier

FLASHGUN TESTER

The downfall of the regular flashgun and bulb arrangement is the all too frequent failure; it usually means wasted film and missing whatever situation was worth photographing in the first place. Composed pictures can always be captured one way or another, but the once-in-a-lifetime shots slip away after that flash fails to do anything but adorn the camera.

If the batteries have failed, or if some other problem has cropped up—like loosely connected cables or a suddenly defective bulb socket—there is an extremely simple and inexpensive way of finding out before any film or time is wasted—or before one of those unforgettable photographic recollections is missed.

HOW IT WORKS

The only components needed, as can be seen from the schematic in Fig. 3-2A, are a tiny neon bulb, a filament transformer, and a discarded flashbulb base. The impulse from the flashgun's battery supply—that would normally fire the bulb—can also be used to energize a neon bulb on the output side of the stepup transformer. It simultaneously checks the condition of the batteries and the cleanness of all associated contacts.

CONSTRUCTION

The test plug that goes into the flash socket is made from the base of a burned-out flash bulb of the appropriate size. Wrap the bulb a few turns in cloth and destroy the glass by striking it with a hammer. Then break away the rest of the glass with pliers and soak the base in boiling water for about five minutes to soften the cement. The rest of the glass can then be removed easily with a screwdriver. Then the old wire

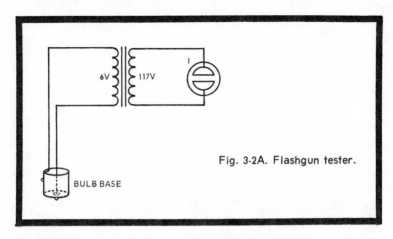

Fig. 3-2A. Flashgun tester.

BULB BASE

connections should be broken; in their place solder a 4 or 5 in. fine two-conductor wire. The plug will be complete after filling the cavity with glue or wax to solidify the whole assembly.

A small box just large enough to contain the transformer is best used to house the unit (Fig. 3-2B). The material used for the enclosure is not important. Two holes in the box should be fitted with rubber grommets—one for securely holding the neon lamp in an exposed position, the other for admitting the leads from the test plug. Two machine screws and nuts will be adequate for securing the small transformer to the enclosure.

USING IT

The test device can be used with or without film in the camera providing the camera does have the automatic-

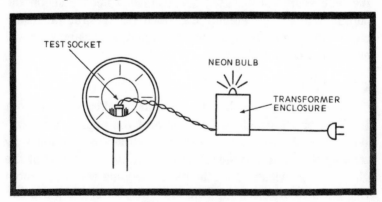

Fig. 3-2B. Using the flashgun tester circuit.

advance feature. Merely cover the lens to avoid fogging the film. If the neon bulb flashes when the shutter is operated, then batteries and contacts are good—if not, a conventional flash bulb will not fire in the same situation, given the same conditions.

The principle of the circuit is so simple that there is hardly anything that can go wrong. If everything in the camera-flash connector is not in tip-top shape, there will be no response from the tester...it's as simple as that. The electronic flash, certainly presenting some of the same problems, is rather inaccessible to this kind of testing because of the presence of lethal voltages in the circuit and flash tube. If you use a flashgun, however, and it doesn't already have a test feature, this simple flashgun tester will provide that essential beforehand assurance.

PARTS LIST

I — Type NE-2 neon lamp
T1 — Low-current filament transformer; 6.3V secondary, 117V primary.

FLASH LIFE EXTENDER

Characteristics of the electronic flash are high-voltage operation, consistently high battery drain, and the nearly "explosive" firing of the flash tube. Even with types that sense reflected light and shut off automatically, the portion of the charge that is not used is dumped through a shunting capacitor. In other words, the batteries, contacts, and flash tube are still sustaining a full discharge. Though there is no question of the soundness of the design of commercial units, the almost mandatory turnover of component parts generally makes it convenient to look the other way when the consumer's dollar is up for grabs. If a unit becomes defective, have it repaired. The increasing complexity and sophistication of equipment makes it seemingly impossible for the photographer to help himself.

The simple **electronic bridge** shown in Fig. 3-3 represents a way to cushion the abnormally high peak voltage that is sent to the contacts of the flash tube. The tube will flash its brightest no matter what the initial voltage is, so long as the average supplied charge meets its firing requirements. You can rest assured that if you connect these two components between battery supply and flash tube, the life of the tube will be substantially lengthened.

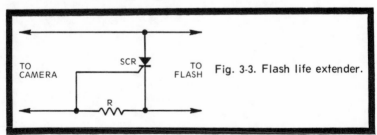

Fig. 3-3. Flash life extender.

The silicon controlled rectifier (SCR) absorbs the initial peak without reducing the overall potential across the contacts. It will not in any way affect the brightness of the flash or the quality of the pictures you are taking. Since the life of the flash tube is probably measured in years anyway, the project does involve a longer-range perspective than it might seem you can immediately benefit from. But how can you lose? The modest investment of less than two dollars can forestall those skyscraping repair and replacement costs that are to everybody's advantage but your own.

PARTS LIST

R — 100-ohm, ½ watt resistor
SCR — 2N3228 silicon controlled rectifier

FLASHGUN BATTERY ELIMINATOR

At home, it often pays to use the wall outlet as a power supply for the flash rather than exhausting your batteries—whether they are rechargeable or not. Having an accessory like the one described in this project can also occasionally save the day when the batteries have grown so weak as not to be functional. This circuit is not meant to recharge the batteries existing in your flash arrangement, but is meant to replace them. As frequently as not, the problem is not the defective flash bulb that you suspected, or even dirty contacts—usually, it's the batteries. With the advent of the automatic film advance, this type of failure has become expensive.

The circuit is basically a power supply that uses a filament transformer and an appropriate rectifier (Fig. 3-4A) to supply 3.5V to the flashgun. The most difficult part of the

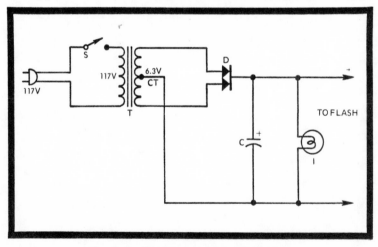

Fig. 3-4A. Flashgun battery eliminator.

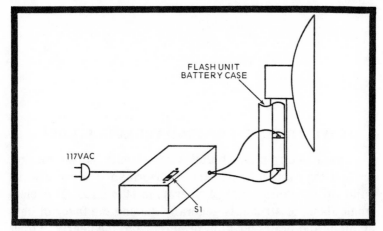

Fig. 3-4B. Using the flashgun battery eliminator.

whole operation is to design an adapter to hook the supply into the battery holder for the flash. The simplest is just to tape the "eliminator" leads to the end of the regular battery and slip the battery back into its holder. It provides failproof results without damaging the battery in any way.

Another approach is to use wooden dowels cut to battery size with the wires securely fastened to each end. Remove the battery and insert the wood mockup whenever you are near enough to an ac receptacle to take advantage of it. For portable applications, just go back to using good batteries.

The supply should be constructed in a small metal housing large enough to contain the six components (Fig. 3-4B). Care should be taken with the high-voltage input leads so the enclosure does not in any way become "hot." Otherwise, assembly and use is as simple as pie. You will find yourself using it on more of your flash shots than you would have expected.

PARTS LIST

C — 250 uF, 6V electrolytic capacitor
D — J29D2
I — GE 47 bulb
S — SPST switch
T — Filament transformer (Stancor P-6134 or equivalent)

SLAVE TRIGGER FOR HIGH-VOLTAGE STROBE

Small electronic flash units are currently on the market for less than $20, although their performance is not always quite up to professional photographic standards. The electronic flash, or strobe, is generally gaining the favor of both amateur and professional in preference to the nearly extinct bulb and flashgun. In the long run, even the more expensive electronic flash units undercut the eventual and sizable cost of using expendable bulbs. What the advent of the low-cost and conveniently compact units means to the amateur photographer is that he doesn't need to be as preoccupied with trying to cut corners and run headlong into the complexities of building his own electronic flash—as might have been the case in the early days of the partnership between electronics and photography. Instead, he can focus on methods to expedite his darkroom operations and other technicalities of the photographer's world. Some of these are jobs that only electronics can accomplish. One of them is the slave flash.

Although the construction of the flash itself might be a bit beyond the realm of the average photographer side-lining in electronics, a slave trigger accessory is within easy reach. The circuit presented in this project will do the job and more. It is light-activated—avoiding the "snaking" and troublesome cords between camera and flash unit; it also avoids the hazard of excessive shutter current that could result from a direct electrical connection. The slave trigger reacts instantly to the master flash and is completely self-contained and portable.

Besides these advantages, it can respond to reflected light at a distance of 20 ft. Although its primary components are tubes, they require no filament voltage and in this special case do not have the usual disadvantages that have made the transistor universally preferred.

46

HOW IT WORKS

The heart of the slave trigger is a gas-filled triode (V2), which operates as a switch (Fig. 3-5A). When at least 150V is applied to the anode of V2, it will fire and trigger the flash unit to which it is connected. The tube is powered by phototube V1. The tube itself generates a trigger voltage for V2 in response to a flash of light from the master flash. In this sense, the phototube is completely self-powered. The only requirement is that the circuit be used with an electronic flash having a capacitor charging voltage of at least 150V.

To determine whether or not this project is what you need for your particular flash unit, **carefully** measure the dc voltage across the contacts of the shutter socket when the "ready" light comes on. The reason for the caution is the presence of a voltage that might just knock you right across the room. This test will also reveal the polarity of the contacts in the socket. You will want to immediately mark the positive side with a **plus** sign.

CONSTRUCTION

Assembly of this unit could not be much more straight-forward. A 2 by 4 in. box (a couple of inches deep) provides just enough room to house V2 and resistor R1, though there won't be much room to spare. Use a slightly larger enclosure if it will be more convenient. Insulate V2 from the enclosure by using spacers beneath its socket.

The phototube (V1) is mounted on the top of the box. To minimize the activation of V1 by stray light, fashion a partial

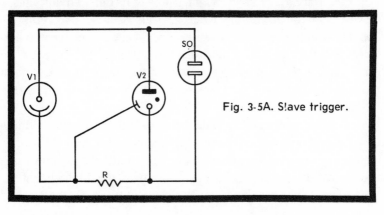

Fig. 3-5A. Slave trigger.

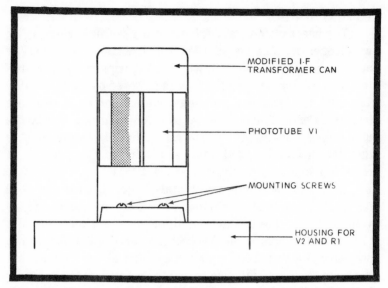

MODIFIED I-F
TRANSFORMER CAN

PHOTOTUBE V1

MOUNTING SCREWS

HOUSING FOR
V2 AND R1

Fig. 3-5B. An i-f transformer can is almost a ready-made shield for phototube V1.

tube cover from the can of an old i-f transformer, as shown in Fig. 3-5B. The trigger is extremely sensitive, and may otherwise react to variations in light level that you cannot predict. The shield can easily be removed or modified for applications requiring greater sensitivity.

USING IT

As mentioned earlier, the use of the trigger with a conventional electronic flash does not call for any modification of the electronic flash itself, which is one of its chief advantages. Even after the strobe has fired, a 50-100V charge can remain on its capacitor for days. The slave trigger, when connected as shown in the schematic, initiates the pulse needed to produce the flash. With an available voltage of 300-1000V, it should not take much argument to convince you to leave the flash itself well enough alone.

Another consequence of dabbling in higher voltages is that the correct **polarity** of the connections between slave trigger and flash are carefully observed. One or both of the units can be seriously damaged if the polarities are inadvertently reversed. Clear markings on the connecting cord, the flash,

and the trigger will forestall any such disaster. Exercising a little care with this trigger will bring you troublefree operation and gratifying photographic results.

PARTS LIST

R — 10M, ½ watt resistor
SO — Chassis-mounting ac receptacle
V1 — 929 vacuum photodiode
V2 — 5823 gas triode

PHOTOFLOOD DIMMER / DISTRIBUTOR

If you've ever had occasion to work with photofloods, then you are aware of this type of bulb's inordinately short life and relatively high cost. The photoflood operates at a voltage (117V) that is twice what it can safely handle (at 65V it would have a normal life expectancy). The result, of course, is an extremely brilliant source of light for photographic applications and a bulb that pays for its brilliance by quickly burning up.

There are several factors that can enhance the photoflood's life. One is to avoid to as great an extent as possible "shocking" the cold filament of the bulb with the surge of current that results from turning it to full power in one leap. This can be arranged by dimming the bulb during sessions when continuous full-power illumination is not necessary. This procedure prevents the bulb from cooling down completely, and economizes on its full power life by operating at half-power most of the time.

The same solution applies itself to all of the problems associated with these bulbs—dim it to half power or less and its life will be at least tripled, perhaps even beyond an entire year of service. If photofloods are one of your problems, the adaptation presented in this project may be of interest.

HOW IT WORKS

In operation, the dimmer is simply using a power diode to half-wave rectify the current supplied to three bulbs. Thus, half of the full operating voltage is removed. Power—as opposed to voltage—is cut even more drastically. The sketches of Fig. 3-6 (A and B) illustrate the wiring of a regular four-socket ac control panel before and after the modification has been made. The circuit modification assumes the use of three photofloods.

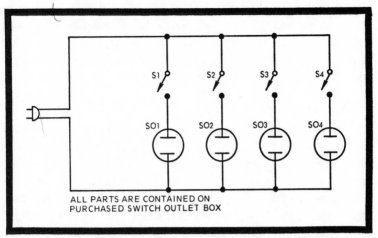

Fig. 3-6A. Wiring of the multioutlet box before modification.

The wiring is changed so that the switch nearest the line-voltage input (S1) is wired in series with the other three switches and sockets rather than in parallel. This means that S1 controls the input to the three parallel circuits, switching the power on and off for the entire panel. When S1 is open, the three control sockets receive power only through D, which is the "dim" condition.

The use of the diode has the advantage of letting any one of the three controlled bulbs be off without affecting the power to the others. It thus doubles as a photoflood distributor. The

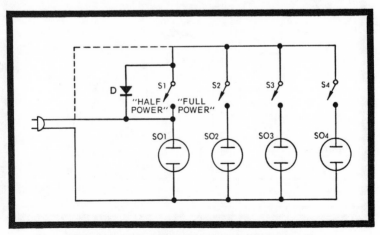

Fig. 3-6B. Photoflood dimmer-distributor circuit.

other chief method for dimming photofloods is series-parallel switching. Although the diode is not needed in this configuration, all of the bulbs must be powered in unison for the trick to work, eliminating all options of different light combinations when in the dim condition.

CONSTRUCTION

The multiple outlet box must be selected with an eye to the wattage of the bulbs that will be used and their number. For instance, three 500-watt (500W) photofloods draw approximately 13 amperes (13A). Sockets rated at 6A and a 15A fuse are selected for use with this combination. The diode specified in the parts list will handle a 200V at 15A. A diode with at least these ratings must be used in a similar situation.

Since the diode is too large to mount inside the multiple outlet box, a small aluminum box that has roughly the same width and depth as the panel will be used to house the diode. Once the diode is mounted in the aluminum box, it will be secured to the end of the panel by drilling two small holes

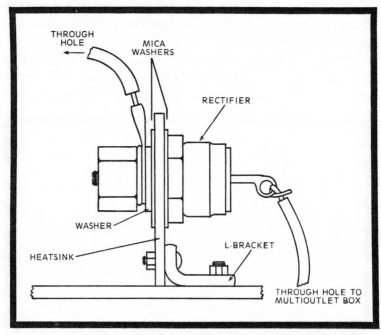

Fig. 3-6C. Diagram showing details for mounting power diode.

through the box and through the end of the panel, then bolting them together with two machine screws and nuts.

Figure 3-6C illustrates the mounting arrangement for the diode (D). Use a small piece of metal as a heatsink. The most important consideration is to completely insulate the component from the heatsink and from the metal enclosure. A nylon bushing can be used around the diode to insulate it from the sink. Mica washers on both sides of the heatsink provide the rest of the protection.

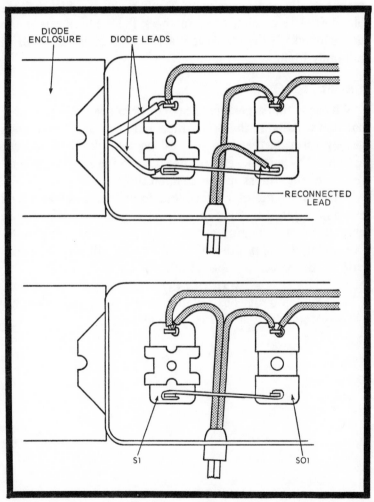

Fig. 3-6D. Multioutlet box wiring, before (top) and after (bottom) modification.

The exact mounting hardware will be dictated by the size and configuration of the diode you have selected.

Use a metal L-bracket to support the diode, as shown in the diagram. The two diode leads—heavy-duty connecting wire—are passed through a hole to join the internal wiring of the multioutlet box. Polarity is of no consequence here.

Refer to the schematic and to the wiring diagram shown in Fig. 3-6D to make the correct changes in the wiring of the circuit. All of the rewired connections should be solid both mechanically and electrically. Don't make any high-voltage blunders. Use an ohmmeter to check the diode in relation to the heatsink. If the insulation is safe, the resistance will be infinitely high.

USING IT

When in the on position, S1 supplies full power to the three parallel sockets. In the off position, only half of the voltage is getting through, meaning that all photofloods in the circuit are dim. The first socket, SO1, has full voltage supplied to it all the time, regardless of the position of S1.

Attach the dimmer-distributor to your tripod where you can easily get at it. Plug in up to three photofloods and then plug the modified multioutlet box into a wall receptacle. Depending on the position of S1, the bulbs will receive either half or full power.

PARTS LIST
Switch outlet box (Waber model 30 or equivalent)
D — Motorola HEP 153 or equivalent.

PHOTOFLOOD LIFESAVER

The circuit presented in this project has never been much of a secret. Those who tire of the sauna-level heat in their studios, or the all too frequent replacement required by the short-lived photoflood bulbs, eventually turn to a simple circuit configuration like the one described in this project to put an end to several headaches at the same time.

It goes by the name of **series-parallel switch**. This circuit is capable of handling two photoflood bulbs. The only real requirement is that the bulbs be of identical wattage. When they are connected in series with each other, they will then receive equal shares of the full-power input. While they each receive half-voltage, their actual operating power is down by two-thirds or so. This means that when they are connected in series, the illumination that they can be expected to provide is one-third that of full-power illumination. Most photographers find that even this fraction of the photoflood's potential brilliance is enough for all preparatory operations. The only time the floods have to be brought up to full intensity is for a final light reading and the actual exposure.

If photofloods are one of your photographic tools, you can easily extend their useful life and do away for the most part with the enormous heat that they radiate if operated at full-power continuously. Two regular ac sockets and a double-pole, double-throw switch represent the major part of the bill of materials. The flip of a conveniently located switch provides either full power or the lifesaving dimming of the bulbs.

CONSTRUCTION

The schematic for the switch configuration is shown in Fig. 3-7A. In actuality, interconnections between the sockets

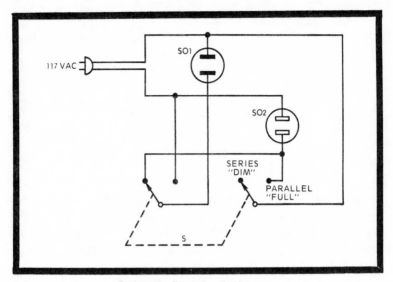

Fig. 3-7A. Photoflood lifesaver.

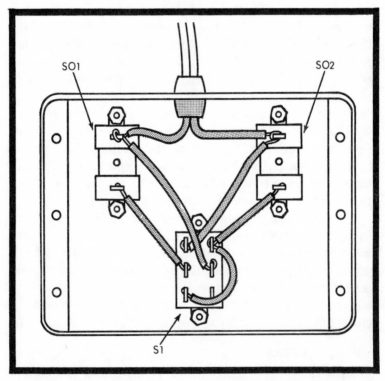

Fig. 3-7B. The simple internal connections of the photoflood lifesaver.

and the switch are a lot simpler than you might gather from the schematic. The wiring diagram is shown in Fig. 3-7B. The metal box should be sturdy, and the switch mounted far enough from the sockets to facilitate easy access. Since the unit might occasionally find its way onto a damp floor, a three-conductor heavy-duty extension cord with a U-ground plug is by far the safest method of connection to adopt. Any unit that might have to stand a lot of handling, and perhaps dragging around, should incorporate this solid chassis ground.

USING IT

The unit can be easily attached to one leg of the tripod with spring-type tool-holding clips bolted to the back of the unit. Plug two photofloods into the sockets, then plug the lifesaver into a wall outlet. Power is immediately supplied. The unit's not having an **off** connection will provide a convenient reminder to unplug the whole affair when you are done.

PARTS LIST

S — DPDT switch
SO1, 2 — Chassis mounting 2-prong ac socket.

PHOTOGRAPHER'S TOUCHUP STYLUS

Most touchup work is most efficiently and artistically accomplished either on the negative or on the nearly finished print. Modification of images, backgrounds, etc. while the print is still light-sensitive can be accomplished only with the general manipulation of the light to which it is exposed. This is usually more general in nature—**blocking in** a relatively large portion of the image, or lightly **burning in** a portion to achieve the desired effect. Generally, a hands-off policy is best.

On the other hand, light is the medium for everything that goes on in photography. Having one more means of producing and controlling the medium is bound to add a bit of a new dimension to your work. The electric **light beam** stylus is a simple and effective way of doing a few creative, if unconventional, experimenting. A narrow pencil of light from a modified penlight photographically blackens the area of an undeveloped print with which it comes in contact. The penlight conversion is rather carefully engineered to eliminate stray light and can do some amazingly precise work considering its low cost and lowly origin.

CONSTRUCTION

A regular penlight is a good point of departure for the construction of the project. Even better would be a commercially available penlight that comes with a curved Lucite extension, and is used for shedding light around dark corners, like the type sold in auto-supply stores for poking around in automobile radiators. The use of the specialized model will save you the trouble of adding the Lucite rod. In any case, what is needed is a short, light-transmitting rod for attachment to the end of the penlight, as shown in Fig. 3-8A. If

you obtain an ordinary penlight and separate rod, use a short piece of nylon tubing and pressfit the two units together.

Though the fitting is plastic, the junction between penlight and rod must **not** be. In other words, don't leave any bending space between rod and the penlight tip.

Shaping the point of the rod is extremely important. Hone it down with a fine ignition file or a pencil sharpener, so that it tapers gradually to a point. The "writing" point of the Lucite rod must be completely, perfectly flat so that in use it will make flawless contact with the smooth surface of the paper. Whether this tip is perpendicular to the light beam or at an oblique angle will depend on what you consider to be the best working angle for yourself. The more oblique the angle, of course, the larger the surface area of the flat tip. Be sure that the angle of the tip will best suit your own skills before finalizing it.

Coat the entire length of the rod (except the tiny flat tip) with opaque or red lacquer—so that the only light leaving the stylus will do so through the tip. Apply at least three coats, being sure to let the previous coat dry before applying another. Keep the lacquer handy until the unit is ready to be tested in case any light leaks are discovered.

The obvious method of powering the penlight bulb is with case-held batteries, making the unit self-contained. One possible variation that has a few advantages is the use of a separate battery supply, as shown in Fig. 3-8B. The battery pack is supported above the drawing board so the light connecting wires will not be a hindrance. Since the penlight bulb is

Fig. 3-8A. (1) Commercially available inspection-type penlight; (2) Lucite rod with light-tight collar; (3) different tapers and tip angles give a variety of light "spot" sizes.

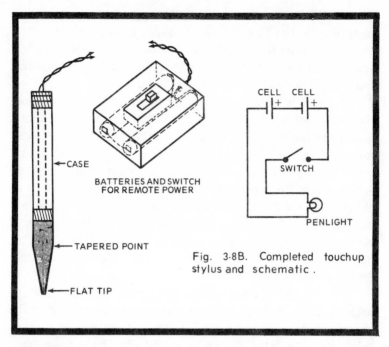

CELL CELL

SWITCH

PENLIGHT

CASE

BATTERIES AND SWITCH
FOR REMOTE POWER

TAPERED POINT

FLAT TIP

Fig. 3-8B. Completed touchup stylus and schematic.

retained in position only with a spring, you may have to jam some putty or other stuffing material into the case after the connecting leads have been soldered to the bulb. Giving the stylus a test run will be the best determination by far of the arrangement that will suit you best.

USING IT

Check out the stylus by turning it on in the darkroom with your eyes adjusted to the darkness. If there are any leaks, retouch with a little more lacquer.

You will be using the electric stylus with undeveloped and perhaps completely unexposed paper. Since you will have to work with the safelight on, choose paper that is certain to have no sensitivity to it. The stylus must be turned on only when the flat tip is in perfect contact with the paper. The same, of course, holds true for turning the stylus off before lifting it from the paper.

The paper grade that you use and the time for which you hold the stylus in one place will determine whether the impressions you leave on the paper are black or gray.

A little trial and error will show you what the stylus can do; in the process, you'll probably even develop the skill to do it. Try it with a ruler, or for signing your name to a photograph, or let the children play with it and draw pictures with the stylus' pinpoint of light, later developing the drawings to a glossy photographic finale to hang on the wall. Don't miss either the serious or the humorous sides of this little device.

PARTS LIST

Penlight — Complete with AA penlight cells, prefocused bulb, and lucite-rod extension (sold as an inspection light).

Switch — SPST slide type.

Housing — small plastic box.

LOW-COST ELECTRONIC THERMOMETER

One factor that many new initiates to the darkroom can ignore for just so long—2 hours or so—is the temperature of their developing solutions. The next move is to run upstairs and get the candy or meat thermometer, then stare at the minute portion of the scale that is of significance in a darkroom.

A better move, of course, would be to acquire the specialized but accurate darkroom thermometer. The mercury thermometer works great, but it certainly has its drawbacks. Besides being hard to read under safelight conditions, this type of thermometer is particularly susceptible to breakage. Then, too, a mercury thermometer is notoriously sluggish in responding to changing thermal conditions.

Most electronic darkroom aids not only take many tedious, critical tasks out of the hands of the darkroom worker, but usually they do the job a little more reliably because of two important premises: fast response and failsafe accuracy. These attributes can be bought at the expense of a minimal amount of time and a mere pittance of out-of-pocket expenditure by throwing together the simple electronic thermometer described here.

Featuring a milliammeter movement, the electronic thermometer has the additional important advantage of being easy to read.

HOW IT WORKS

In this circuit (Fig. 3-9A) the temperature-sensitive thermistor (R1) regulates the current passing through the coil of the milliammeter (M). Meter deflection is thus the direct result of the thermistor's resistance—which in turn

corresponds in a predictable way to the temperature of the surrounding medium. Any temperature change is registered instantly on the meter, since the time taken for the temperature gradient to pass through the material of which the thermistor is made is negligible.

CONSTRUCTION

Layout of the circuit's six components should cause no perplexity. Any small metal box that has a large enough surface area to accommodate the meter movement and potentiometer (R2) will be a good enclosure. Any of the various sizes and shapes in which milliammeter movements are available will work equally well. Calibration will be better with a larger scale. A suggested layout is pictured in Fig. 3-9B.

The special part of any electronic thermometer is the thermistor. In this circuit it is the remote sensor for responding to the temperatures of liquids. To monitor room temperature, you would probably mount the thermistor right on the meter enclosure. In the darkroom it is generally advisable to keep things loose, so the leads from the sensor should enter the meter circuit through a miniature plug and jack. The thermistor can then be disconnected and stashed away in a safe place when not in use.

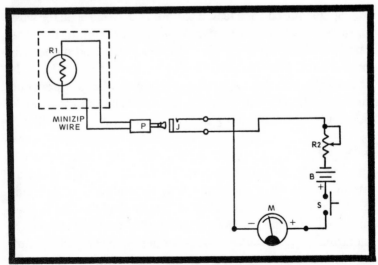

Fig. 3-9A. Electronic thermometer.

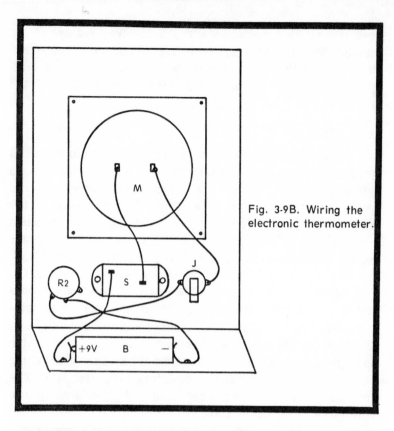

Fig. 3-9B. Wiring the electronic thermometer.

Solder one end of a length of "minizip" (fine speaker wire) to the leads of the thermistor; and connect them at the other end to a miniature plug (P). The thermistor and its exposed connections have to be absolutely waterproof. Coat the thermistor and the soldered connections with a waterproof liquid-plastic cement. It can then be attached to the end of a stirring rod or something similar for convenient handling.

USING IT

Pressing the momentary-contact switch (S) will cause the meter to deflect a given amount, depending on the temperature that the thermistor is responding to. Use a thermometer of known accuracy to calibrate the meter of the electronic thermometer. The potentiometer (R2) will enable you to set your temperature range to the center of the meter scale.

appropriate increments. Replace the faceplate and you're in business.

The meter will be marked in units, probably from 0 to 1 or 0 to 10. Keep a written record of meter indications at various temperatures. When your list is complete, remove the meter's plastic faceplate and carefully scribe the temperatures at the

PARTS LIST

B	—	9V battery
M	—	0-1 mA dc milliammeter
J	—	Jack (any type)
P	—	Plug (to mate with jack)
R1	—	Thermistor (Fenwall GB41P2)
R2	—	10K linear-taper potentiometer
S	—	SPST momentary-contact switch

THREE-BULB PHOTOFLOOD DIMMER

The much-used photoflood lamps in both home and professional studios are essentially ordinary tungsten lamps designed for normal operation at 65V, but which are operated at 117V. The light output of a lamp increases tremendously with an increase in voltage. In fact, a voltage boost of even 40 percent doubles the light. Unfortunately, this also severely compromises the useful life of the bulb. It is for this reason that photoflood lamps have a life of only a few hours, instead of the much longer life of an ordinary bulb. It is possible to lengthen the life of these lamps by connecting two or more photofloods of the same size in series, making them burn at half-voltage or less (depending on whether two or three bulbs are used); then, when everything is ready for the exposure, a throw of the switch puts the two lines in parallel, which means equal and full power to each bulb again.

Photofloods operated in this manner have been known to last better than a year, because they are on at full power for only a few seconds. The schematic for a three-bulb series-

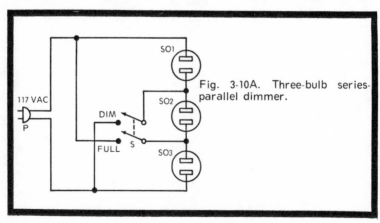

Fig. 3-10A. Three-bulb series-parallel dimmer.

parallel switch is shown in Fig. 3-10A. In the FULL position of S, all bulbs are at full power. In the DIM position, the output of all three bulbs is dramatically reduced.

Emitted light falls off much faster than the voltage as the voltage decreases if you use bulbs of unequal voltage. You will find that the contrast between your flood intensities is much more pronounced in the series condition than would be expected from the hardly noticeable differences at full power.

The reason, of course, for adhering to the equal-power criterion for the bulbs is that you are apt to find it difficult to compose and focus under one lighting situation, then take a picture under what are actually substantially different lighting conditions.

The cost of the circuit is reasonable—keeping in mind that photoflood bulbs are much dearer to the storekeeper than a small collection of electrical hardware—and the additional benefits of being able to exert a little more control over

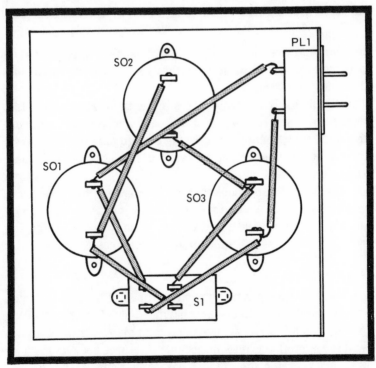

Fig. 3-10B. Internal wiring of dimmer.

Fig. 3-10C. The small control box can be mounted to a tripod.

lighting and over general studio atmosphere should heavily outweigh any small reluctance that you may have to dig into the work involved.

Figure 3-10B illustrates the simplicity of the wiring. Most important is the insulation of all leads and connections from the small metal control box. Using a male plug on the chassis for the power connection makes it possible to use a regular extension cord.

Don't waste any hookup wire for serpentine connections inside the box. Short and to-the-point connections, with good, sound mechanical and soldered connections at the socket and switch terminals, will guarantee trouble-free operation.

USING IT

Use two spring-type clips on the back of the box to fasten the dimmer control to one of the tripod legs (Fig. 3-10C). Plug the box into a heavy extension cord and plug your three equal-wattage photofloods into the sockets. All three sockets must be used in order for the control box to work in its "dimmer"

capacity, since any unused socket would remove the possibility of two bulbs being connected in series. Any one of the sockets, or any combination of the three—will conduct full power when S1 has been flipped into its FULL position, which places all the sockets in a parallel configuration.

PARTS LIST

P — chassis-mounting U-ground ac plug.
S — DPST switch
SO1, 2, 3 — Chassis-mounting ac receptacle

Section 4

Intermediate Projects

AUTOMATING YOUR SLIDE PROJECTOR

What better way can there be to add that professional air to your photo slide shows than to bring a little "robot" into your employ and have him do the work while you sit in the audience? As an accessory to your semiautomatic slide projector, this circuit is ideal for showing slides one after another at regular intervals. The duration of projector "hold" before switching is regulated through a useful range—from 15 to about 120 seconds.

Actually, any electrical device that operates in a semiautomatic fashion and is normally controlled with a momentary-action pushbutton switch may be converted to 100-percent automatic repetitive-cycling operation with this project. Perhaps the most interesting and useful aspect of all is that the original equipment does not need to be modified in any significant way. All that is required is that the "automatic" control be connected across the terminals of the switch on the equipment. The control can be overridden or turned off at any time without any other connections or disconnections. Even with the automatic control circuit in operation, the projector or other device can still be controlled with the manual switch.

HOW IT WORKS

The circuit is a basic relaxation oscillator, firing the neon bulb periodically (Fig. 4-1A). The components of the oscillator portion of the circuit are capacitor C1, resistor R1, potentiometer R2, and neon bulb I. The capacitor is charged through the two resistors. When it is charged sufficiently—to approximately 60V—the neon bulb will fire. The process of charging and firing will then repeat.

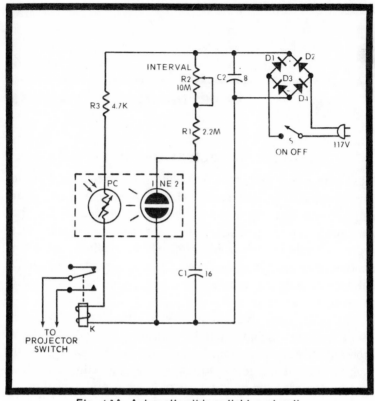

Fig. 4-1A. Automatic slide-switching circuit.

The frequency of lamp ignition depends on the values of C1, R1, and R2, as well as the voltage across the entire circuit. Since R2 is adjustable, it is easy to vary the frequency of the triggering action according to individual needs.

This simple repetitive action, however, is only half the story. The oscillator itself does not directly control the action of the relay (K). Instead, the neon is close-coupled to the photocell (PC) located in the relay circuit. In the absence of light from the neon bulb, the combined resistance of PC and R3 prevent the relay from energizing. But as light from the neon bulb strikes the sensitive surface of the photocell, its resistance decreases and allows a sufficient flow of current to energize and close the relay. Connected in parallel with the switch on the projector, the relay contacts simulate the function of the manual switch.

Capacitor C2 acts as a power supply filter. Instead of using the four individual diodes called for in the parts list, the experimenter might find it more expedient to substitute one of the many commercially available rectifier bridge modules. Either method is satisfactory. Modifying the circuit in any way will do nothing more drastic than alter its frequency characteristics.

CONSTRUCTION

Not much more could be said about the circuit's economical use of space and electronic components. It is even possible to build the whole circuit inside the projector near the switch assembly. The only precaution to take if you decide to do this is to keep the components well away from the hot projector lamp, as the heat can damage the electrolytic capacitors or resistors. It is preferable to use a separate enclosure for the circuit, facilitating its use with other equipment should the need arise.

Any enclosure is satisfactory, since nothing in the circuit is particularly critical. A small aluminum box is the best bet. Several methods are available for mechanically coupling the light-sensitive resistor to the neon bulb. It is possible to use plastic or masking tape, or even a number of tightly wrapped rubber bands. Since extraneous light can interfere with the operation of the circuit—causing sporadic triggering—an opaque shield is necessary. The simple and convenient method used in the prototype made use of a plastic insulator of the type used on alligator clips. Figure 4-1B shows this method of coupling. If the insulator is too long, a little bit can be cut off each end. It is also a good idea to slip a little insulating sleeving over the leads of the two components to prevent short-circuiting.

Fig. 4-1B. The type of insulator used over alligator clips is a convenient method of close-coupling photocell to neon bulb.

Fig. 4-1C. Mount a plug on the enclosure for greater versatility.

The only components that must be on the outside of the small chassis are **interval** control R2 and **on-off** switch S. The importance of adequate insulation in the internal connections cannot be overemphasized, since the rectifying diodes (D1-4) and switch (S) are connected directly to the power line. Since there is no chassis ground in the device, an enclosure other than metal such as a plastic instrument case can easily be substituted. Connect the diodes with careful attention to their polarities.

USING IT

After the assembly has been checked and the circuit is assembled in its enclosure, close it up and plug it into an ac outlet. After turning switch S to the **on** position, the relay should start pulling in and out at a regular interval. The maximum and minimum settings of potentiometer R2 should produce intervals of about 2 minutes and 15 seconds, respectively. If so desired, a dial plate with the appropriate calibration can be placed under the knob of R2.

A small-size plug on the chassis, with mating socket and cord from the pushbutton in the projector, is ideal for the control connections (Fig. 4-1C). Set up the projector as usual and let the "robot" circuit do its work. If you want to view a slide for a longer period than the control circuit will allow, simply turn off the robot until you are ready to continue. If you want to quickly change the slide, pushing the switch on the

projector will do it without interrupting the even sequence produced by the control unit.

To change the effective frequency range of the timer, change the value of resistor R1. Changing the value of C1 will also affect the control frequencies that are available. Once you have adjusted the circuit's operation to your liking, with a little time and effort, you will have in actuality acquired a more expensive and sophisticated slide projector—one of the automatic models.

PARTS LIST

C1	— 16 uF, 150V electrolytic capacitor
C2	— 8 uF, 150V electrolytic capacitor
D1-4	— 200 PIV, 1A diodes (T1 1003)
I	— NE-2 neon lamp
K	— SPDT relay, 10K coil (Potter & Brumfield LB5)
PC	— Clairex CL504 photocell
R1	— 2.2M, ½-watt resistor
R2	— 10M linear-taper potentiometer
R3	— 4.7K, ½-watt resistor
S	— SPST switch

LIGHT METER

Although most currently available cameras feature at least one built-in light meter, the reading is an interpretation of light relative to the camera, shutter-speed, aperture, etc. for which it is designed. Even among the built-ins, there is more to tell than the picture on the cover—whether, for instance, it is an **average** intensity that is being metered, or an indication of a more selective "spot" sensitivity.

Most meters featured in cameras are the averaging type. Many photographers—even if they are using an electronic flash with automatic flash shutoff—find that a separate "workhorse" light meter comes in handy for a double-check or for a deliberate under or overexposure that the camera itself is not designed to accurately measure. The simple light-meter project discussed here may provide that additional versatility for the many unusual photographic situations that require it.

The strong advantages this meter has over commercially available devices are the easier readability of its wider scale, the ruggedness of its milliammeter movement (rather than the commercial instrument's delicate microammeter movement), extremely low cost, and adjustable sensitivity over a wide range. Using only two small batteries, this device features an extremely low current drain, which means long battery life.

HOW IT WORKS

Circuit operation could not be much simpler. The voltage present on the base of transistor Q (Fig. 4-2A) depends on the resistance in the photocell (PC), which in turn depends on the amount of light it receives. The photocell's resistance is inversely proportional to the amount of light reaching it. Additional regulation is provided by the calibration control (R1).

Potentiometer R4 readjusts the milliammeter circuit each time it is used, insuring that repetitive accuracy will be high. The transistor serves the main purpose of isolating the photocell from the meter, providing a current "gate" for the meter coil.

CONSTRUCTION

A construction plan is simple for a project consisting of so few noncritical components. Several options—such as meter size—are open to you, depending on your anticipated application for the meter. There is no reason not to use one of the many available miniature meters with the same basic deflection sensitivity as the device specified in the parts list. The only problem created by a smaller instrument is that the faceplate becomes harder to read and calibrate accurately. The longer the scale, the better—so long as you don't mind the increased size.

The transistor and the other small components may be mounted on a small piece of perforated or drilled circuit board, which can be secured to the enclosure with the meter mounting hardware. The heavy-duty nature and simplicity of the device permits the use of machine screws and nuts for the

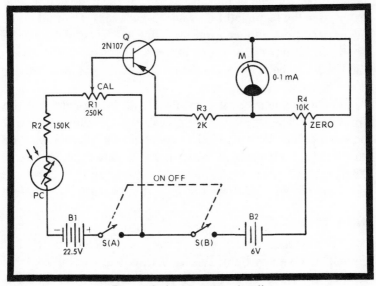

Fig. 4-2A. Light meter circuit.

Fig. 4-2B. One possible arrangement of light meter controls.

connections. Be sure to make a good, solid mechanical connection for the transistor; this will preclude the eventuality of heat damage while soldering.

The photocell must be positioned on the external surface of the chassis. An obvious advantage in positioning the photocell on the end of the chassis is that the photocell will be exposed to the same light as your camera lens. Drill a hole to accommodate a rubber grommet that will securely hold the photocell in place. For more directional sensitivity, a short, light-tight "tube" can be fashioned around the cell with tape or some other opaque material.

For convenience, all controls should be mounted on the front panel. The smaller the meter enclosure, the tighter will be the squeeze to mount all of them on the one panel. One convenient front-panel arrangement is shown in Fig. 4-2B. This layout allows easy reading of the meter and full access to the controls without compromising the photocell's function.

HOW TO USE IT

To test your light meter, cover the photocell so that it cannot receive any light. Rotate both potentiometer controls fully clockwise and turn the unit on. The meter will register a small deflection to the right. Use the **zero** control (R4) to bring

the meter to a zero reading. Uncover the photocell and allow it to be exposed to a small amount of light. The meter will now show a positive reading. Increasing the amount of light will cause the meter to deflect farther to the right. Move the light meter closer to the light source until a full-scale deflection is obtained. Then, by slowly decreasing the setting of R1, the meter will drop smoothly toward zero.

Increase the meter setting again until the meter shows full deflection. Covering the photocell again should cause the indicator to return to zero again. If you cannot obtain the same readings and behavior under identical lighting conditions by going through this procedure several times, the transistor might be faulty. Otherwise, it should be clear sailing.

Using the meter concurrently with another light meter of known accuracy and sensitivity will enable you to remake the milliammeter face to correspond to readings of light intensities. Different settings of potentiometer R1 will require different scales, though. So when you calibrate your light meter, be sure to also note the positions of your panel controls.

PARTS LIST

B1 — 22.5V battery
B2 — 6V battery
M — 0-1 mA milliammeter movement (dc)
PC — Clairex CL505 photocell
Q — 2N107 (or any general purpose pnp amplifier)
R1 — 250K, linear-taper potentiometer
R2 — 150K, 1-watt resistor
R3 — 2K, ½-watt resistor
R4 — 10K, linear-taper potentiometer
S1 — DPST switch

LIGHT-SENSITIVE RELAY

A light-sensitive relay acts basically as an **on** or **off** control for an electric device. Although its many uses are not limited to photography, the photographic applications are by no means few. You might like to have an automatic shutoff for room illumination as the enlarger lamp is turned on—or exactly the reverse situation, with the enlarger lamp going on automatically as room lights are turned off. Or wire a safelight so that it will turn on as room lights are turned off. A simple device can act in the darkroom as a "third eye" to detect unwanted light, such as from a door ajar.

A particularly attractive use would be that of automatically turning on a "do not enter" lamp above the darkroom door each time the darkroom lights are off while the master power switch in the room is on.

A wide variety of possibilities are available to the builder of the simple and inexpensive light-operated relay described in this project. It can be connected for either an **on** or **off** function, and it operates directly from a household outlet. The action of the photo activator device does not vary as the light intensity increases beyond a certain threshold sensitivity which is set with potentiometer R1 (Fig. 4-3A).

HOW IT WORKS

Transistors Q1 and Q2 act as a regenerative switch, forming a high-impedance network until the voltage across them and related components reaches a sufficient and predetermined level. When this level is reached—and not before—the switch fires. The triggering occurs when light strikes the photocell, decreasing its resistance and so increasing the current at the base of Q1. When the regenerative switch conducts, the relay (K) energizes, pulling in the armature to

close its contacts. The switch will not fire as long as no light falls on the photocell. Potentiometer R4 determines the amount of light required to close the relay.

The voltage across the regenerative switch is half-wave rectified, meaning that it will trigger only on each positive half-cycle. This in no way detracts, however, from the sensitivity of the device.

CONSTRUCTION

Nothing in the circuit is particularly critical. The main consideration is that most of the circuit operates at a dangerously high voltage. For this reason there is no chassis ground and the entire circuit must be enclosed. Any size box sufficient to hold all the components and having enough surface area to accommodate the ac receptacle (SO), potentiometer (R1), and the externally mounted photocell (PC) will be adequate. A wood or plastic enclosure is possible in this case because the entire circuit will remain insulated from its surroundings. Most of the components should be mounted on a single piece of perforated circuit board (perfboard) which is secured to the enclosure with spacers. If a metal enclosure is used, be sure to insulate the frame of the relay, because the frame is attached electrically to the armature, and will thus be carrying full power-line voltage.

Sound household-wiring precautions should be used in assembling this unit. There must be no long, loose leads

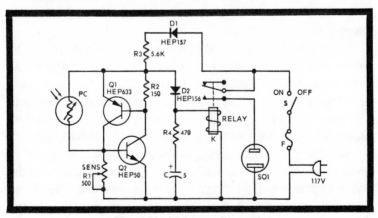

Fig. 4-3A. Light-sensitive relay.

between relay and the device that it controls. Tape-insulate all high-voltage connections and provide strain relief for the ac line coming into the circuit. Don't forget the fuse. It acts as protection for both the light-sensitive relay and for the external device that will draw its power through the relay contacts.

The heart of the circuit, of course, is the photocell. Depending on the uses you have in mind for the circuit, you will probably want to make custom modifications to suit your particular need. Mount the cell on the front or top of the enclosure, and use a rubber grommet to hold the cell in place (with the tiny window at its end facing outwards, naturally). For general ambient light reception, the window should have as wide an angle of reception as possible. If it is to be activated by a specific source, it can be made more directional by fashioning a small hood or tube with light-blocking tape or paper—or even an alligator-clip insulator such as that employed in the previous project.

If you have a "remote" application in mind, the cell itself can be fitted with a plug and an appropriate jack mounted on the chassis. The cell and its heavy-duty connecting leads may then be routed to the desired location and can be easily disconnected—perhaps only to plug in a photocell at another location for another application. For a more permanent remote installation, more than one photocell can be wired into the circuit in parallel through a series switch, as shown in Fig. 4-3B.

USING IT

Once everything is wired and checked, insert the fuse in its holder and plug the device in. Plug in a lamp or other low-current household appliance. Depending on how you have wired the relay contacts, the normal position of the contacts will represent either an **on** or an **off** condition. If wired as shown in Fig. 4-3A the external device will be normally off.

By incorporating an additional socket and wiring the relay contacts as shown in Fig. 4-3C, you get the best of both worlds. One receptacle will be "alive" in darkness and "dead" in ambient light, while the other will perform in precisely the reverse sequence.

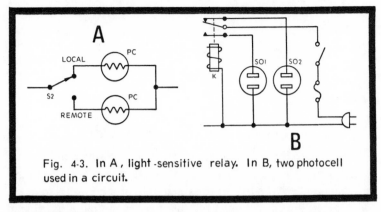

Fig. 4-3. In A, light-sensitive relay. In B, two photocell used in a circuit.

CHECKOUT

With no light shining on the photocell turn the sensitivity control (SENS) fully counterclockwise. Then expose the cell to normal room light and advance the control until the relay pulls in. At a low setting of the sensitivity control, the light-operated relay should be fairly sensitive. At a high setting, it will take light of greater intensity to trigger the relay. Trial and error will easily determine the best sensitivity setting for specific applications.

PARTS LIST

C	— 5 uF, 15V electrolytic
D1	— HEP 157 diode (silicon)
D2	— HEP 156 diode (silicon)
F	— Fuse (2A)
K	— SPDT relay; 350-ohm, 12V coil (Potter & Brumfield RS5D)
PC	— Clairex CL505L photocell
Q1	— HEP 633; pnp transistor
Q2	— HEP 50; npn transistor
R1	— 500-ohm, linear-taper potentiometer
R2	— 150-ohm, ½-watt resistor
R3	— 5.6K, ½-watt resistor
R4	— 470-ohm, ½-watt resistor
S1	— SPST switch
S2	— SPDT switch (optional)
SO1, 2	— Chassis-mounting ac sockets (one optional)

All HEP devices listed are Motorola types.

BATTERY-CAPACITOR FLASH GUN

Although the old flashgun and disposable flash bulbs seem to be losing ground to the electronic flash, there are still many photographers who prefer the flash bulb and continue to use it with great success, based no doubt on techniques developed after decades of experience. It is understandable that photographers with those years of experience might be reluctant to lose a favorite tool.

Electronic flash enthusiasts like the photos their equipment can help them get. The same is true of the people devoted to flash bulbs. Who will insist that the much simpler approach of the battery-capacitor flashgun is not a bit superior in cases?

The design presented in this project is a simple and nearly universal flashgun circuit. The chief virtue of the circuit is that it isolates the heavy bulb-firing current from the delicate camera shutter contacts, which would inevitably be damaged after extended use of the flash.

HOW IT WORKS

A transistor (Q) acts as a gate for the large voltage charge developed across capacitor C (Fig. 4-4A). The transistor is reverse-biased by the small positive voltage across R1. This bias prevents the discharge of C and the firing of the bulb. Notice that C charges slowly through R1, R2, **and** the high resistance of the flash bulb itself. Current never rises to a sufficient level during charging to fire the bulb. When C reaches full charge, the circuit has reached an equilibrium.

The triggering circuit remains ready until switch S is pressed or the camera contacts close the circuit in coincidence with shutter action. Closing the previously open circuit negatively biases Q, causing the transistor to conduct almost as readily as would a simple short-circuit. The surging current

fires the flash bulb. The circuit then remains completely open until another bulb is inserted in the socket and its resistance again plays a part in the gradual voltage buildup across C. A few seconds and the system is ready to go again.

CONSTRUCTION

The flashgun makes use of a separate battery power supply. Any such supply is satisfactory if it can sustain the multiple-flash current drain that practical use would demand. The "shoulder bag" approach is generally preferred for rapid-fire sessions, or where a recharge or a replacement battery is inconvenient. Although all of the other components in the circuit can be enclosed with the battery in the pack, it is better to mount a small housing for the circuit along with the reflector and bulb next to the camera with a cable extending to the battery pack for power. (See Fig. 4-4B.)

A small aluminum mixing bowl or an inexpensive commercial flash reflector is secured to the side of the small metal enclosure. In the side of the flash head assembly is mounted a PC-type socket, selected to match your camera's PC cord. The pushbutton switch, mounted on the top or back of the flash head box—provides easily accessible manual control of the flash.

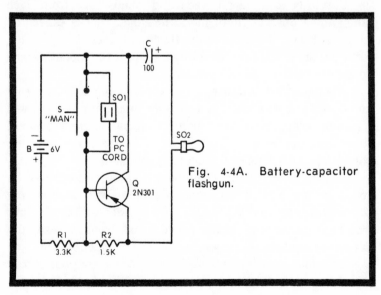

Fig. 4-4A. Battery-capacitor flashgun.

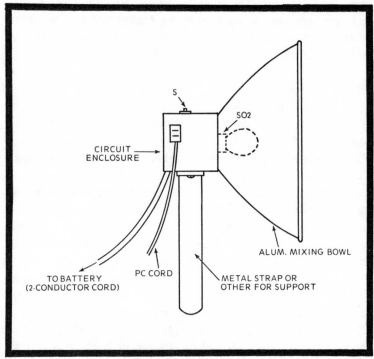

Fig. 4-4B. One suggested approach to flashgun design.

Carefully insulate all leads and connections from each other and from the small metal housing. This is especially important with the leads to the flash bulb socket. A four-lug terminal strip will provide enough support for mounting and connecting the small components.

When the flash is in use, the power cord has to be securely connected at both ends. The best way to accomplish this will no doubt be apparent once you get your particular version of this circuit under way. The choice will be between a direct connection or a plug-and-socket arrangement.

As long as the specified component values are adhered to, you wind up with a functional flashgun with almost any physical format that you might care to adopt. Since the unit will have to survive fairly rugged and frequent use, the durability and the actual strength of the connections that you make become very important. Fasten a handle of your choice to the base of the flash head, then make it attachable in turn to

the base of the camera with a thumbscrew fitting, and the flash attachment is ready to go.

USING IT

Remember that the charging capacitor remains dormant until a bulb is inserted in the socket of the flashgun. After the bulb is inserted, a few seconds' wait will bring the flash to ready. First time around, use the manual-control pushbutton for a test. If all is well, connect the PC cord between camera and flash. Just to be safe, connect the PC cord without a bulb in the socket. The slight chance of accidental firing will thereby be eliminated.

All elements of the device are inexpensive and easily obtainable. Construction and operation is neither difficult nor dangerous. The result: that reliable standby—the battery-capacitor flashgun.

PARTS LIST

B — 6V battery
C — 100 uF, 15V electrolytic
Q — 2N301 pnp transistor
R1 — 3.3K, ½-watt resistor
R2 — 1.5K, ½-watt resistor
S — SPST, momentary-contact switch
 (normally open)
SO1— Chassis-mounting ac receptacle
SO2— Socket (to match flash bulb)

TAPE-AND-SLIDE SYNCHRONIZER

Color slides are a true joy to have and to show. If your work on that last vacation was as good as you wanted to be, you may even have mailboxes full of invitations to present your slides and give a running commentary on them. If you do occasionally give talks on your slides and trips, you probably know well the tedium of trying to present the same talk over and over again while simultaneously and automatically operating the slide projector.

The problem can be simply and easily handled by recording your talk beforehand on a stereo tape recorder. You do this by putting your voice on one channel and recording synchronizing pulses on the other channel to operate your slide projector at the appropriate moments. The link between projector and tape is the circuit described in this project.

The unit is used during both recording and playback—first to generate the signals that will actuate the projector, those use these signals to perform the actual switching action that operates the slide projector. Since slide turnover is controlled by you, the operator, the switching times can be as irregular and sporadic as you deem necessary. The device is economical and should not take more than two hours to assemble. The initial requirements, of course, are a stereo tape recorder and slide projector.

HOW IT WORKS

The central component of the circuit, shown in the schematic of Fig. 4-5A, is a triac. This component is essentially a bidirectional SCR, the gate of which can be triggered with a voltage of either positive or negative polarity.

When switch S1 is pressed, two things happen: The triac (Q) conducts and power is supplied to make the slide projector

motor advance through one cycle. At the same time, the 60 Hz current passing through the triac is passed to the secondary of transformer T. In the primary of T, a 60 Hz voltage appropriate for a recorder-input appears. When the synchronizer is in the **record** mode, this signal is used for the triggering pulse that is recorded on the nonspeech channel of the tape. The level of this signal is regulated with potentiometer R3.

In the **playback** mode (switch S2), the output of the synchronized channel is fed to the primary of T1. The voltage is stepped up slightly and then passed to Q, triggering it into conduction and causing the slide-projector motor to cycle. Pressing S1 will override all automatic controls and advance the projector no matter what else is going on.

CONSTRUCTION

The only thing important in the layout of the few components used in the circuit is convenience. A box large enough to accommodate all controls plus the four central components is the only requirement as far as the enclosure goes. A 5 by 7 in. aluminum box (about 3 in. deep) is just about right.

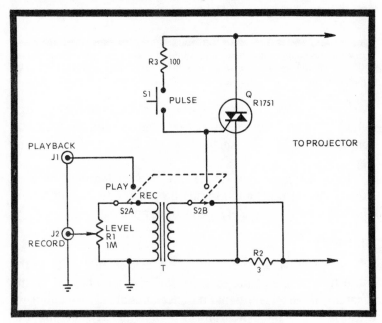

Fig. 4-5A. Tape-and-slide synchronizer.

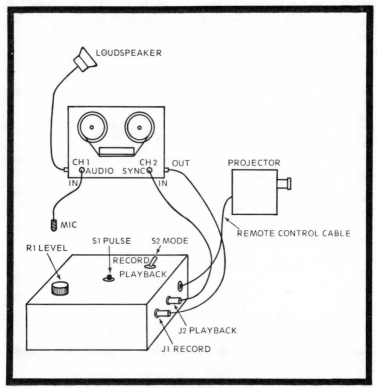

Fig. 4-5B. Diagram showing the completed tape-and-slide synchronizer and the interconnections between synchronizer, tape recorder, and slide projector.

Since no ground is needed, and the circuit will contain high voltages, an enclosure of plastic or wood is suitable. External connections (Fig. 4-5B) should be made through the side of the box.

In choosing a value for R1, the current required by your slide projector mechanism must be taken into consideration. The voltage at the base of R1 should be approximately 1V.

USING IT

To record your speech and the synchronizing pulse at the same time, connect the microphone into one channel of the recorder in the conventional manner. A cable is then run from the J2 output of the synchronizer to the other channel input of the stereo recorder. Then connect the slide projector through

its remote control socket—or with a direct electrical connection to the terminals of its pushbutton switch—to the power connection in the synchronizer as it is shown in the schematic. The nature of this hookup will depend on your individual situation.

Figure 4-5C illustrates the use of a matching plug for a remote-control socket on a projector that features it. It is also possible to make the connection into the synchronizer with a plug-and-socket arrangement. Since the dual-lead conductor will be handling line voltages, this unit should be chosen accordingly. The triac's "shorting" these two leads together simulates the action of a pushbutton switch. When everything is set, adjust the level of the synchronizer-to-tape input with potentiometer R1. As you record your speech, merely press S1 to change slides and record the signal to do so at a later date on the tape.

When playing the tape back, put S1 in the **playback position, switch the connecting cable between the synchronizer and the recorder to J1 and to the appropriate speaker output on the recorder.** Play the tape back and you will hear your speaking voice on one channel and nothing on the other. The projector will change slides on cue as programed during the recording session.

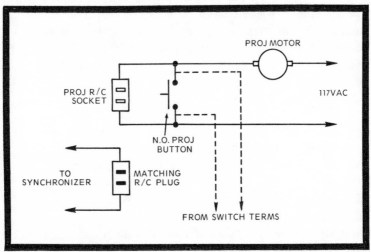

Fig. 4-5C. Use your projector's remote-control socket or wire directly to its pushbutton terminals.

Fig. 4-5D. A remote switch for the synchronizer itself may prove convenient.

Both semiautomatic and regular slide projectors may be used with the device. In the case of semiautomatic operation, a cam switch in the projector responds to the short triggering action of the switch and then continues to supply power to the motor until one complete cycle is finished. With a regular-type projector, the switch is held down until the slide change is complete. The action of S1 on the synchronizer will have to be appropriate for the type of projector being used.

If so desired, a remote switch for the synchronizer can be connected across S2, as shown in Fig. 4-5D. This will enable you to operate the synchronizer while not in the immediate vicinity—similar to the advantages of having a remote switch on the slide projector itself. It is, of course, completely optional. The materials required for the modification are a cable-mount pushbutton switch with cord and plug, and an appropriate socket for it on the synchronizer enclosure.

PARTS LIST

J1, 2 — "RCA" type phono jacks
Q — Triac, Motorola R1751 or equivalent
R1 — 1M, audio-taper potentiometer
R2 — 3 ohm, 5-watt wirewound resistor
R3 — 100 ohm, 5-watt resistor
S1 — SPST pushbutton switch (normally open)
S2 — DPDT switch
T — Audio output transformer (Stancor TA-62)

LOW-COST CLOSEUP FLASH

You may wonder where this oddball device fits into the photographic order of things. It is a close relative of the expendable flash bulb, operating at a much higher voltage and current than it would seemingly be capable of; but it is not "expendable." This factor brings it nearer the realm of the electronic flash. The closeup flash uses an incandescent flasher-type bulb, and consequently comes to rest somewhere in the middle, since its effective candlepower or watt-second rating does not really approach that of either flash bulb or electronic flash.

The unit described in this project does the job of a "little" flash, coming in very handy in closeup applications where the ordinary flash—and even a more distant slave flash—turns half the exposure a gleaming white and leaves the shadowed portions of the subject underexposed. The incandescent closeup flash is camera-triggered, contains its own battery supply, and provides consistent fill-in lighting for otherwise awkward closeup shots.

HOW IT WORKS

The schematic for the project is shown in Fig. 4-6A. The 22.5V battery (B) charges capacitor C through current-limiting resistor R1. With a fresh battery, charging time will be about 20 seconds. A battery that has seen some prior use may take up to 30 seconds to prepare the flash for operation again.

In its normal state, the SCR acts like an open circuit and allows no current to flow through it. When a low-level positive pulse is supplied from the camera contacts, however, the SCR conducts very suddenly, and a surge of current fires the lamp (I). The special advantage of using the SCR is that it

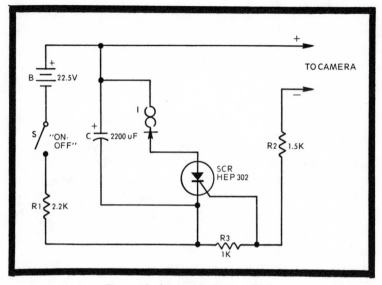

Fig. 4-6A. Low-cost closeup flash.

represents a very small load and is not apt to electrically damage the camera's shutter contacts.

Hardly less essential is the special incandescent lamp that contains a built-in circuit breaker. As soon as the filament reaches a certain critical temperature, the connection is broken and the bulb does not burn out. This is the reason that a 22.5V supply can be used with a bulb rated at only 6V. The bulb flashes very brightly, considering its limitations, and remains operative for as many repeat performances as you have photographic persistence.

CONSTRUCTION

The circuit uses relatively few components and can easily be assembled in a 2 by 4 in. plastic "parts" box. The reflector for the lamp may be salvaged from an old flashlight. Cut a hole for it at one end of the front of the case. It can be secured to the case with epoxy. Other holes of appropriate dimensions will be needed for power switch S and for the activator cord that will be connected to the camera when the unit is in use.

A four-lug terminal strip should be all that is needed to connect and secure all the other components (except battery). All connections going directly to the positive side of the bat-

94

tery can be run straight to a common bus wire (or to the enclosure itself if you're using a metal chassis).

The electrical connection to the camera flash contacts is made with a flash fitting and length of cable, both of which should be available from your local camera shop. Be sure to take your camera along to make sure the flash fitting fits.

Run the cable through a rubber-grommeted hole in the chassis and connect it as shown in the schematic. This particular connection offers less leeway than any other for mistakes. To avoid damage to both camera and flash, double-check the polarity, then double-check it again.

If you want to attach your closeup flash directly to the camera, the answer lies in your scrap sheet metal. A 6 in. length of heavy-gage aluminum, drilled to accommodate a thumbscrew fitting for attachment to the bottom of the camera, and screwed directly to the base of the closeup-flash case at the other end will complete the construction process.

The flashlight reflector contains a ready-made socket for the lamp. Solder connecting leads to the appropriate places on the socket. When the unit is complete, screw the bulb into the socket and it is ready to go.

USING IT

There is no exposure guide number for this little flash, so a little trial-and-error experimentation will be needed before you start getting perfect results. The camera should be set for a normal bulb flash.

The flash duration of the incandescent bulb used in the unit is slightly shorter than for a conventional flash bulb, and it does not produce as much light. This means that you should not expect too much at great distances or with slow film. Remember that the unit is designed for that special closeup work that has been unapproachable with the conventional flash.

Best results will be obtained using a fairly slow shutter speed. The slow shutter speed also tends to eliminate the problem of the incandescent flash being a little slow-reacting by nature. Occasionally, the charging capacitor may not completely discharge, creating a condition in the circuit in

AG-1 SOCKET

Fig. 4-6B. Wire a flash bulb socket as shown for alternate use.

which the SCR will continue to conduct. Although this will not damage the lamp, the capacitor will not be able to begin recharging. If the problem arises, quickly switch the on-off toggle a time or two.

A decided advantage of the closeup flash is that the voltage available across capacitor C is also great enough to flash a conventional flash bulb. If you find that the closeup flash occasionally doesn't measure up for the application you have in mind, the basic circuit and enclosure is easily modified to include an AG-1 flash bulb socket for alternate use as a full-power flash. It is wired in parallel with I, as shown in Fig. 4-6B. Again on a rather tiny scale, the reflector for the flash bulb can be made from an old stainless steel spoon. Figure 4-6C shows the physical arrangement of spoon, clamp,

SPOON

AG-1 FLASH BULB HOLDER

SPRING-CLIP

PORTION OF SPOON USED AS CLAMP

CLOSEUP FLASH ENCLOSURE

Fig. 4-6C. Diagram of a simple homemade reflector for the AG-1 flash bulb option.

spring-clip, and socket in one possible approach to this modification.

When the flash bulb is inserted into its socket, this bulb becomes the master flash and the incandescent bulb quietly fades into the scenery. If the two are fired simultaneously for a closeup application, put the shutter down an extra stop.

You will find that the closeup flash will get you away from the problem of washed-out closeups. It is one way to become less helpless in the face of the invariably scorching high-power flash.

PARTS LIST

B — 22.5 battery
C — 2200 uF, 25V electrolytic
I — Flasher bulb, 6.5V (GE 405)
R1 — 2.2K, ½-watt resistor
R2 — 1.5K, ½-watt resistor
R3 — 1K, ½-watt resistor
S — SPST switch
SCR — Motorola HEP 302 silicon controlled rectifier

THE SIMPLEST DARKROOM TIMER

Most commercially available timers, although accurate, are on the expensive side. Even the more sophisticated do-it-yourself models that automatically do all your clock-watching and switch-throwing may be a little farther than you want to go for a first step. If you have been finding it increasingly vital to your darkroom operations to time your exposures more accurately than is possible with a glow-in-the-dark wrist-watch, the economical circuit described in this project may be just what you are looking for.

The circuit—containing no relays, transistors, or tubes—will provide accurate timing for all of your printing and enlarging needs. The timer-indicator consists of two small lights mounted side-by-side on the timer enclosure. Under normal darkroom conditions, the pale orange glow of these small lamps is completely safe. One lamp blinks at the rate of one blink every 5 seconds, the other at the rate of one blink every second. As is probably evident, any required time can be counted off using first the 5-second timer, and then—if the required time is not evenly divisible by five—counting off the remaining time on the 1-second timer. The circuit does not use batteries, so the first financial outlay for the device will probably be the last.

HOW IT WORKS

The timer in its entirety (Fig. 4-7A) consists of two interlocked neon-bulb relaxation oscillators that operate at different rates. Transformer T and its associated components step the line voltage up to about 150V. This half-wave rectified voltage is then applied to both relaxation oscillators.

The first oscillator circuit is formed by I1, R5,R4, and C2. The remaining components—I2, R3, R2, and C3—form the

second oscillator. They are coupled electrically through capacitor C4. The charging capacitor in each circuit gradually accumulates a charge through its associated resistors, one of which is a potentiometer. When the charge on the capacitor reaches a sufficient level—60-70V—the neon bulb, wired in parallel with the capacitor, fires. When the voltage on each capacitor falls below the level needed to maintain the bulb in a conducting state, the capacitor begins charging again and the cycle repeats itself. The charging time for the I1 circuit is one second. The I2 circuit—because it contains a capacitor of much higher value—repeats approximately every 5 seconds. Notice that the value of C3 is exactly five times the value of C2.

CONSTRUCTION

All components needed for the timer are inexpensive and readily available. Since the circuit needs no chassis ground, any material that suits your fancy can be used to house the circuit. The size of transformer T1 will be the main consideration. Component layout is not critical, so mounting the transformer on the bottom of the enclosure for reasonable stability is a good idea. Four two-lug terminal strips provide support for the rest of the components.

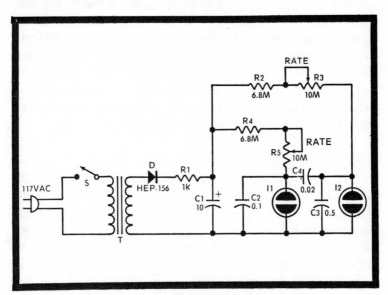

Fig. 4-7A. The "simplest" darkroom timer.

Fig. 4-7B. Completed darkroom timer.

Potentiometers R5 and R3 are mounted on the same panel, preferably on top, as shown in Fig. 4-7B. The two neon bulbs can be fastened behind two small holes in the side of the enclosure with cable clamps. Watch the polarities of the electrolytic capacitor (C1) and of the power supply diode (D). All connections should be made with insulated hookup wire to provide added insurance against what could become a dangerously hot chassis in the event that a metal enclosure has been used.

If you have a junkbox of components on hand, you may want to try a substitution or two. Several of the component values in the circuit may be changed without affecting the overall operation of the circuit. The power supply components—with the exception of the transformer—will accept any substitution within a reasonable range. Any element of either of the timing circuits that is changed can significantly alter the time characteristics of its oscillator.

USING IT

Once everything has been wired and checked, plug the timer in. After a slight pause, both of the bulbs will begin flashing. This testing should be undertaken in a partially darkened room so that the bulbs can be easily seen. Use the sweep second hand of a clock or wristwatch as a standard, and adjust potentiometer R5 until the appropriate lamp blinks at precise 1-second intervals. Then adjust R3 to bring the rate of I2 to exactly 5 seconds. I1 should blink four times, then be

100

joined on the fifth blink by I2. You don't have to be much of a math wizard to successfully and accurately use this simple timer to further your photographic ends. 33 seconds, for instance, can be pinpointed by counting 6 blinks of I2 and then 3 of I1. The blinking is completely regular, which makes it easy to anticipate the appearance of the blink that you are looking for.

The timer calibration, after it is set initially, will occasionally need to be readjusted, especially if the timer has not been used for an extended period of time.

PARTS LIST

C1 — 10 uF, 150V electrolytic
C2 — 0.1 uF capacitor
C3 — 0.5 uF capacitor
C4 — 0.02 uF capacitor
D — Motorola HEP 156, silicon diode
I1, 2 — NE-2 neon bulbs
R1 — 1K, ½-watt resistor
R2, 4 — 6.8M, ½-watt resistors
R3, 5 — 10M linear-taper potentiometers
S — SPST switch
T — Transformer (Thorardson 23V17)

REMOTE-CONTROL SHUTTER-RELEASE

While it may seem farfetched, you can construct a device to operate your camera's shutter from a signal you send from 200 to 300 ft away. If you want to enter the intriguing realm of nature photography, or if you have an automatic film advance and want to get into some time-lapse work, you may find this project of considerable interest. The device will operate any camera that can be fitted with an ordinary 2 ft shutter-release cable. As long as you are careful in executing the mechanical aspects of construction, the control device will be both functional and durable.

The mechanical linkage suggested here is only one of many possibilities. Regardless of the linkage you decide upon, however, you must be certain that the moving parts will not be loose. If the linkage is not tight, it will be intermittent in character and thus of little real usefulness. In other words, if you are planning to construct the remotely operated solenoid, be prepared to put enough time into it to do the job right the first time.

HOW IT WORKS

A distant momentary-action switch does all the work. You can use a lamp cord between switch and control box up to a thousand feet long if a particularly heavy cord is used. The trick is not to lose the electrical connection to the switch with connecting leads whose length offers excessive resistance.

When you close switch S, a small current flows to the base of transistor Q (Fig. 4-8A). This action turns the transistor on and sends current surging through the coil of solenoid K. At this point, the electronic phase of the remote control operation is finished and the mechanical task begins. The arm of the solenoid is forcefully pulled in, and the pivot arm (Fig. 4-8B),

to which the solenoid arm is connected, presses against the plunger of the firmly secured shutter-release cable. When appropriately adjusted with potentiometer R1, this force will be just enough to release the shutter.

CONSTRUCTION

There are few hard-and-fast rules to follow in the construction procedure for this project. All that is necessary is that it be fairly sound both mechanically and electronically, and that the finished product be reliable for application in a wide range of situations—from a difficult wildlife shot to the hidden camera planted by a practical joker or spy.

The metal enclosure that is selected to house the unit must be sturdy enough to provide a foot-hold for the solenoid. The force of the solenoid is applied from two sides of the enclosure to an adjacent side. Select an enclosure heavy enough not to buckle under the applied force, and light enough to be fastened securely to the camera's support. An exit hole is cut through one end of the box. When the solenoid frame is bolted to the box, the solenoid arm is centered through the exit hole.

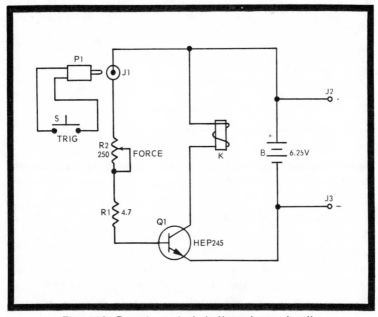

Fig. 4-8A. Remote control shutter-release circuit.

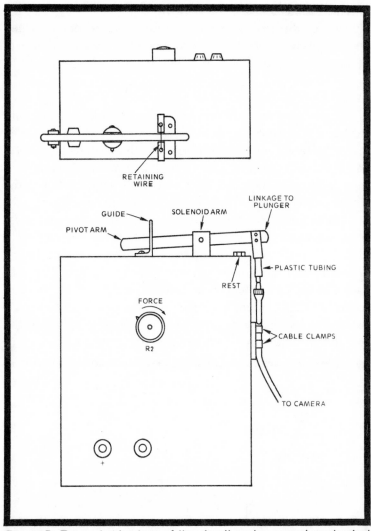

Fig. 4-8B. Top and side views of the circuit enclosure and mechanical linkages.

The solenoid arm meets a pivot arm which, in turn, is joined through a simple mechanical linkage to the plunger of the shutter-release cable. An inexpensive cable of this type can be purchased at any camera shop. Using it with the remote-control unit does not require any modification.

The cable is clamped tightly to a slightly elevated block of wood or metal on the side of the enclosure with cable clamps of

the appropriate size. It is extremely important that the cable be fastened securely in this location, since the force of the solenoid ultimately requires this solid base to push against. The spring tension of the plunger—operated against the immovable barrel at the end of the cable—constitutes the force that the solenoid must overcome.

The material that the pivot arm is made from will be dictated by personal preference and the availability of metalworking equipment. Metal is desirable on the basis of its durability and strength, but a wooden bar of the same dimensions will also do the job. If you use wood, however, be sure that the force is applied across its width rather than depth. The best way to construct the pivot joint to the solenoid arm is to notch the arm to form a bracket for the pivot, applying force then with a screw that penetrates both. Whatever arrangement you decide upon, the pivot arm must be able to swivel a bit as the solenoid arm pulls in.

Note also the use of a stabilizing guide at the one end of the pivot arm to keep it in place. A short retaining wire or strip is fastened to the top of the guide to keep the arm from escaping. The arm will normally be at rest at the bottom of the guide. All force is then being applied in the direction of the solenoid arm itself—rather than at an angle that would be less effective— and is transmitted by the other end of the pivot arm to the plunger of the shutter-release cable.

The simplest way to construct this last step in the linkage is to use a short length of plastic tubing, pressfit over the plunger head and over a peg or screw in the end of the pivot arm. If you want the joint to be permanent, and can spare the cable, substitute heat-shrinkable tubing for the pressfit. There must not be enough slack between the two joined pieces to absorb the solenoid arm's movement.

Remember that even a little leeway in each of the joints of the linkage could be enough to ruin the effectiveness of your carefully designed assembly. Remember also that the solenoid arm is released almost as quickly as it is pulled in, meaning that every joint in the linkage should work equally well in both directions. Additionally, the greatest strength of the enclosure is along lines that are parallel or perpendicular

to its own lines. All motion in the device should be along these lines.

An L-bracket mounted inside the enclosure will serve to mount the transistor and the resistor in the circuit. The battery is secured to the other side of this bracket. Connections to the solenoid leads, battery, and jack for the connection of the remote switch are made with heavy-duty hookup wire, since the current drawn by the solenoid is on the order of 2.5A. The transistor isolates the remote switch from this heavy current, making possible lighter connecting leads for the remote extension than would otherwise be feasible.

The unusual current requirement of the solenoid makes nickel-cadmium rechargeable batteries a worthwhile investment, especially if you are anticipating extensive and frequent use of the unit. Two additional jacks on the enclosure's top panel will facilitate recharging the batteries. Be careful to mark the polarity of the jacks. Significant damage to the circuit could result from confusing the polarities of the charging voltage. Potentiometer R1 is mounted on the top panel of the enclosure. This **FORCE** control will require careful adjustment when the device is actually put to work.

USING IT

Securely support the unit near your camera and clamp the cable barrel in place. You will want to attach the plastic tubing to the plunger and pivot-arm peg before finally positioning the cable under the clamps. Plug in remote switch S, turn R1 to its minimum setting, and start experimenting with the action of the solenoid. Loosen the cable clamps and bring the cable barrel close enough to the pivot arm so that the plunger is depressed almost—but not quite—to the point of shutter release. Then advance R1 until the force of the solenoid is just enough to push the plunger the fraction of an inch required to trigger the shutter.

You will then be ready to traipse off into the distance, trailing the connecting cord for the remote switch, and be confident that pressing the switch will automatically and instantaneously get the shot that has always been impossible when you were around.

If you have an automatic film-advance feature on your camera, the remote control will provide you with repeat exposures. Another idea might be to use a photoelectric relay in place of switch S, which would allow snapping a picture as the light of dawn or the darkness of nightfall makes its appearance. There is hardly an end to the ingenious ways in which you can use this device.

PARTS LIST

B	— Five 1.25V nickel-cadmium cells
J1, P1	— Mating plug and jack (such as phono type)
J2, 3	— Banana jack
Q	— Motorola HEP 245, npn transistor
R1	— 47-ohm, 1-watt resistor
R2	— 250-ohm, 5-watt potentiometer
S	— SPST pushbutton switch (normally open)
K	— Solenoid, 2-ohm coil (Guardian No. 11)

DARKROOM METER

With modern darkroom techniques and electronic aids, virtually anything that goes wrong with the initial exposure—whether it is underexposed, overexposed, or slightly out of focus—can be corrected with skillful printing work. The object is to achieve precise control over every phase in the development of the photograph. The truly excellent photographer will have all the options and possibilities—from the field work to the darkroom—floating in his mind as he takes the picture.

One of the most critical steps in the process, where the photographer has strong rein over the results, is in the enlarger exposure. It is essential to be able to measure the light intensity over the enlarger easel, to be able to repeat the measurement with extreme accuracy, to be able to have an accurate indication of contrast by comparing the light and dark portions of an image, and then be able to translate that comparison into the best exposure time and paper grade for the exposure. It is, of course, much less simple than it sounds. Intimacy and familiarity with one's own equipment is imperative, whether the equipment be homemade or commercial.

The darkroom meter described in this project will provide a reliable control and guide to getting that perfect print every time. Once it has been calibrated, it will become second-in-charge in the darkroom. It features a broad-scale milliammeter for easy reading and calibration. It is also comparatively simple and inexpensive, and is the perfect first step for the person who is a little hesitant about jumping into the caldron of photographic expenses.

HOW IT WORKS

The schematic for the darkroom meter is shown in Fig. 4-9A. A bridge circuit is formed by transistors Q1 and Q2

and resistors R5 and R6. When the voltage across this bridge is balanced, no current flows through milliammeter M. The bridge rectifier formed by diodes D1-4 permits an unbalanced current reading in either direction, meaning that the variable resistance of photocell PC can be measured over a wider range.

The values of resistors R4-6 are chosen for a full-scale meter deflection with maximum unbalanced current through the bridge. Potentiometer R3, with PC at a fixed resistance, governs how unbalanced the circuit is and how much current will flow through the meter coil. Conversely, with the potentiometer at a fixed setting, variations in the resistance of PC—in response to different light intensities—will control the action of the meter.

As can be seen, the function of the milliammeter in the circuit is to relate the setting of R3 to the condition of PC.

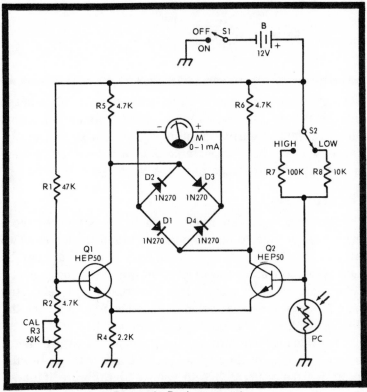

Fig. 4-9A. Darkroom meter.

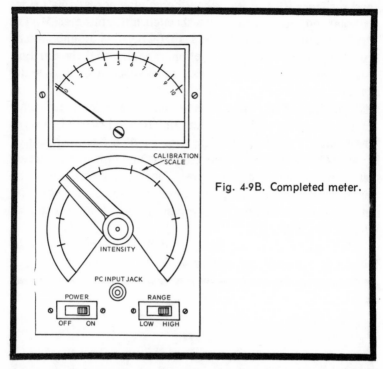

Fig. 4-9B. Completed meter.

When PC is exposed to a constant light intensity, R3 is set to balance the circuit and produce a zero meter deflection. Different light intensities require a different setting of R3. Hence, you will have repeatable pinpoint accuracy in identifying exposure readings over a wide range.

CONSTRUCTION

The main requirement for the enclosure is that it have a large enough face to accommodate the milliammeter. Two multilug terminal strips or a single piece of perfboard can be used to support and connect most of the unit's components. Potentiometer R3 is mounted on the front panel below the meter. Power and range-selector switches S1 and S2 are the other controls to be mounted on the front panel.

A design idea that may be of help is to use as large a radius for the dial-plate of R3 as you can. The larger the scale, the better will be your ability to read and calibrate it under semidark conditions. Figure 4-9B shows a convenient

arrangement that makes use of more of the enclosure's surface area.

If it will make things easier, meters of the type used in this project are available in many different sizes—from cumbersome to microminiature. Since its only function is to register zero in response to a correct setting of R3, a relatively small meter will serve the purpose quite well.

Another entirely separate matter is the photocell itself. For maximum versatility and usefulness, the photocell must be mounted separately from the rest of the circuit. One very convenient method for handling and protecting the cell is shown in Fig. 4-9C. Use the existing holes in a small piece of perfboard. Another piece of board—the same size as the first—is cemented behind the first to form a sandwich, with the leads of the photocell firmly clamped between the two boards. If necessary, connect the photocell leads to longer lengths of insulated connecting wire before cementing the boards together.

Connection of the photocell into the meter circuit is perhaps best accomplished with a phono plug and jack. Since the cell itself is quite delicate, you should store it separately from the meter circuit when it is not in use. Another point in the phono plug's favor is the unusual hazard presented by dangling cords in the darkroom.

The darkroom meter does not have its own meter illumination. Since the circuit is designed for use with an

Fig. 4-9C. The photocell can be sandwiched between two small pieces of perfboard.

enlarger, and all measurements are apt to be made with the enlarger lamp on, it is usually enough to place the meter near enough to the lamp to be read by its reflected light.

USING IT

Get started with this meter by test-stripping and then using your regular methods to produce the perfect print. Connect the photocell and turn the unit on. Place the cell directly over a point of interest on the image and adjust R3 until the meter falls to zero. Shift the cell to another location, again adjusting R3 for zero meter deflection. Make a note of these readings, using tentative markings on R3's dial plate for a reference.

Whatever method of calibration is used, the meter readings have to be referenced to a table or manual that can reveal correct exposure time and paper contrast for that particular situation. For commercial exposure meters, the table is compiled by the manufacturer on the basis of tests and experiments with the meter. With a homemade meter, this table is compiled by the manufacturer on the basis of your experience with the meter in a variety of situations. Manufacturers do most of the work beforehand and mass produce the results of their efforts. Your work with the meter will be a find of "subjective" standardization.

Start a logbook to record the readings of the exposure meter in different situations. The several columns that will be used to record your readings should include paper grade, exposure time, enlarger setting, and the settings of R3 over the brightest, darkest, most detailed and other areas of interest on the image. A little space left for other notes and the identification of the print is also a good idea.

The direct mathematical relationship between different readings and intensities will gradually become apparent. For instance, in two of your entries all parameters will be identical—with the exception of time and light intensity. If such is the case, and the time was cut in half on the second entry, then the ratio of the light intensities was also 2:1. Before long, your logbook will be comprehensive enough to be a sure thing in its applicability to any printing requirement.

112

To extend or limit the darkroom meter's ranges as they stand now, substitute higher or lower values for resistors R7 and R8. If you choose a different photocell—perhaps a cell with the same resistance but a higher sensitivity to low-level light intensities—you will also have to follow through and adjust the other resistances in the circuit accordingly. Maximum setting of R3 in the **low** range represents 6 foot-candles. In the **high** range, the same setting represents approximately 400 foot-candles.

PARTS LIST

B	— 12V battery
D1-4	— 1N270 diodes
M	— 0-1 mA milliammeter (dc)
PC	— Clairex CL505L photocell
Q1, 2	— Motorola HEP 50 npn transistor
R1	— 47K, ½-watt resistor
R2, 5, 6	— 4.7K, ½-watt resistors
R3	— 50K, linear-taper potentiometer
R4	— 2.2K, ½-watt resistor
R7	— 100K, ½-watt resistor
R8	— 10K, ½-watt resistor
S	— SPDT switch

VARIABLE-DURATION TIMED CONTROL CIRCUIT

If you have the impression that the more complicated a circuit is—the more semiconductors of all shapes and sizes that it contains—the more useful it will be, you're wrong. The circuit (Fig. 4-10A) of the variable-duration timer described in this project uses only four active components and a small battery. It has a range from 5 to 50 seconds and is adjustable continuously through this range. Its relay contacts will control anything from an enlarger lamp to a 1 5V electric motor. The timer can be calibrated with an eye to your own needs.

HOW IT WORKS

Operation of the circuit depends on the discharge of capacitor C through the coil of relay K. Under normal conditions, with switch S in its normally open state, there is no current whatever flowing in the circuit.

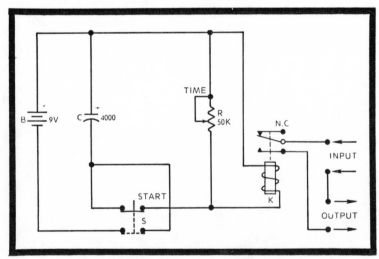

Fig. 4-10A. Variable-duration control circuit.

A charge is built up across C and stays there until the timing sequence is initiated. When pushbutton S is pressed, the capacitor is disconnected from the relay and accumulates a charge as fast as battery B can produce it.

After a few seconds the capacitor is fully charged. If S is now released, the capacitor is reconnected to the relay and begins to discharge through the relay's coil and through potentiometer R. Sufficient current is flowing through the relay to energize it and close its contacts. It remains energized until the capacitor has been almost completely discharged. This interval of activation is the timing sequence of the circuit. The setting of potentiometer R determines the on time of the relay.

CONSTRUCTION

Component layout is not critical. Any box large enough to hold the handful of components will be adequate. Four regular binding posts are used for external connection to the relay contacts. If you will be using the timing circuit to control a high-voltage electrical device, you might want to use two ac sockets for the input and output of the relay. Either way, the customary precautions for dealing with dangerous voltages should be taken. Figure 4-10B illustrates the relay connections, showing a direct line-voltage hookup on the input side and an ac socket on the output side. Connection of the simpler binding post arrangement is also shown.

USING IT

The best way to calibrate the variable-duration control circuit is with an ohmmeter and a stopwatch. Fasten a blank card temporarily under R as a dial plate. Nothing is connected to the relay contacts at this point. Short the input terminals together and the calibration can begin. The resistance across the output terminals will alternate between infinite and zero as the relay opens and closes, respectively. Set potentiometer R1 to its minimum position—fully clockwise—and mark the position **ZERO**. All other settings as the control is turned in a counterclockwise direction will increase the interval for which the relay contacts will be closed.

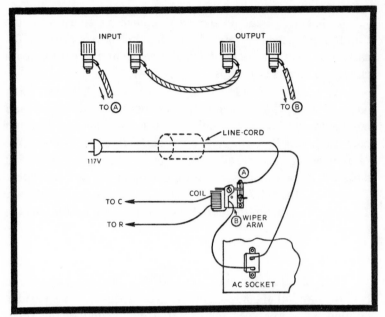

Fig. 4-10B. Diagram showing output connections with binding posts (top) or ac socket.

Press S for 4 or 5 seconds. As you release the switch, start the watch and keep an eye on the ohmmeter across the output. After a very short delay it will jump to a negligible resistance reading. Stop the watch as the meter swings back to the infinite resistance reading. The watch will have recorded the timing sequence from beginning to end for this particular setting of the potentiometer. Calibration can then be completed by advancing R and marking the durations of interest (1 second, 5 seconds, etc.). The timer is then ready to perform reliably in a wide variety of darkroom applications. Ultraprecise the the timer may not be, but simple it certainly is.

PARTS LIST

B — 9V battery
C — 4000 uF, 15V electrolytic
K — SPST relay, 8K coil (Sigma 4F-8000S-SIL)
R — 50K, linear-taper potentiometer
S — SPDT pushbutton switch (normally closed)

LOW-VOLTAGE ELECTRONIC FLASH SLAVE

If your electronic flash operates at less than 150V, then this simple slave trigger is probably what you have been looking for. The normal firing voltages of flash units with fairly high-power output start at 300V and proceed upward. It is sometimes difficult to come by accessory circuits for lower power units that enhance their operation instead of being merely a disastrous mismatch.

To establish whether this slave trigger is applicable to your unit, it will be necessary to carefully measure the voltage across the flash-to-camera contacts of the flash unit, or dig out the fact sheet that came with the unit. If you do attempt the direct measurement, clearly mark the polarity of the contacts for later use.

HOW IT WORKS

Gas tube V2's function (Fig. 4-11A) is to simulate the action of the camera's shutter contacts. The tube will not conduct until there is at least a 150V potential across its cathode and anode. Even then, the tube requires a high-voltage pulse on its trigger electrode. This pulse is generated by phototube V1 in response to any bright flash of light. Since the flash unit itself cannot provide the potential across the terminals of V1, four series batteries that add up to 180V provide the additional impetus. As the conditions are met for the firing of V1, the tube is momentarily short-circuited; this action triggers the electronic flash unit.

CONSTRUCTION

A small metal enclosure large enough to contain V2, the battery supply, and the few other components in the circuit will be the basic requirement for the construction of the unit. A

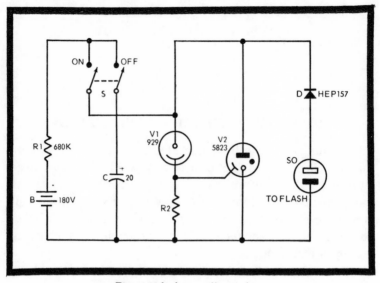

Fig. 4-11A. Low-voltage slave.

socket for phototube V1 is mounted on the top of the enclosure. Mount switch S and an appropriate plug or socket for the flash sync connections on the side of the case. Use a modified i-f can from a discarded radio or a similar-size "can" to shield the phototube, as shown in Fig. 4-11B.

Fig. 4-11B. Completed low-voltage slave with shield.

USING IT

This slave trigger will be sensitive to the pulse of the master flash up to a distance of at least 20 ft. This may depend on the presence of reflected light and on the power of the master flash. You will find this sensitivity more than adequate for most situations in which the trigger and slave flash are needed. Plug the flash control cord into the trigger circuit. Be sure switch S is in its **on** position. A little trial and error will determine the maximum distance at which the slave will be useful; a quick test run will tell you if there are any extraneous light levels that will trigger the flash accidentally. The unit requires careful positioning in the direction of the master flash for best results.

PARTS LIST

B — 180V battery (four 45V in series)
C — 20 uF, 250V electrolytic
D — Motorola HEP 157 silicon diode
R1 — 680K, ½-watt resistor
R2 — 10M, ½-watt resistor
S — DPST switch
SO — Chassis-mounting ac receptacle
V1 — 929 phototube
V2 — 5823 gas-filled triode

ENLARGER TIME-TENDER

If your darkroom has been seeing more of you lately than your workbench has, then it won't hurt too much to draft your vacuum-tube voltmeter into service as one part of a sensitive and reliable exposure meter. Despite the apparent simplicity, the exposure meter is very reliable and will prove invaluable in helping you pinpoint the correct exposure time for that next print—and is even a fair hand at calling out paper grade.

The enlarger exposure meter—governing those relationships between light intensity, paper grade, and negative density—is virtually the cornerstone of modern precision printing. A person who becomes familiar with such a meter becomes so sure of himself and his equipment that he would be willing to tear up a whole roll of prize negatives after corresponding prints had been exposed—and this is before he has even a preliminary glimpse of the results. What his equipment maps out, of course, are the steps to be taken to insure that negatives of extremely poor caliber come out of the darkroom looking like the best. The technique? A good exposure meter is a crucial link in the chain.

The meter described in this project takes advantage of the high input impedance of a VTVM or other similar instrument (such as a field-effect transistor meter or equivalent). Add a few components that you may have to go only as far as your junkbox to find. A little construction time and the time-tender will be ready to begin its partnership with your enlarger. The simple additional circuit requires no power supply of its own.

When you begin to trust more than your eyeballs and paper grade and time tables, you may be a little embarrassed that you haven't worked hard for this remarkable solution to the problem of inconsistency in printing.

The meter indicates exposure times from 0 to 100 seconds and provides a direct reading of negative contrast. A slight modification of the VTVM itself is required. The modifications do not in any way affect the normal operation of the VTVM. If the time-tender sounds like a gold mine for the price of pennies—assuming that you already have a VTVM available—it is!

HOW IT WORKS

Check to see if your VTVM has a 10 in the middle of the ohms scale. If it does, it has the required nonlinear scale. If it also has a 1 meg range, you are in business.

Photocell PC reduces its resistance in direct proportion to increasing light intensity. Plotting this response on a graph—intensity vs resistance—produces a straight line. The VTVM, as an ohmmeter, thus provides a direct indication of light intensity. Resistors R1 and R2 are a provision for controlling the sensitivity of the device, making it useful under a wide variety of operating conditions. (See Fig. 4-12A.) The two switches in the circuits (S1 and S2) make it possible to make zero and full-scale adjustments on the VTVM without having to disconnect the accessory circuit. The modification of the VTVM and its external hookup is shown in Fig. 4-12B.

CONSTRUCTION

When you have all the components on hand, check potentiometer for smooth response through its complete

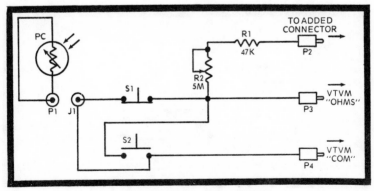

Fig. 4-12A. Enlarger time-tender.

Fig. 4-12B. Diagram showing the two changes necessary inside the VTVM.

range. If all is well, mount R1, R2, S1, S2, and J1 in a small box. The material used for the box is not important, nor is component layout critical aside from having the controls mounted for convenience. (See Fig. 4-12C.) Three leads terminating in regular test plugs are needed for connections to the VTVM. The other ends of these leads are wired directly into the adapter circuit; a single rubber-grommeted hole in the adapter-circuit enclosure collects the leads. A 0-100 dial plate is mounted under the R1 control on the panel. Set the plate to read zero when R1 is in a fully counterclockwise position.

The photocell can be secured between two pieces of insulated circuit board, with its sensitive face exposed through a hole in one of them. After connecting leads from the photocell

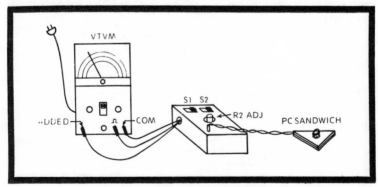

Fig. 4-12C. Completed time-tender.

to plug P1, cement the boards together and you have an instant crush-resistant sensor that will be able to sustain frequent handling and use.

The VTVM itself requires two things—an extra jack and one lead connected between the new jack and the Rx1M scale-resistor junction, as shown in the schematic. Opening the meter and making the two additions should be a simple and painless matter. Trace the connection from the **ohms** terminal on the front panel to locate the correct resistor. The range-selector for the ohmmeter is set to reading resistance with the Rx1M multiplication factor for this and all subsequent readings. Meter illumination is best "tapped" from the enlarger lamp, as all readings will be made with the lamp on.

USING IT

The time-tender at this point is ready to be tested. Set the meter to the ohmmeter mode; then turn it on and use S2 and S1 to adjust the meter to zero and full scale.

With R1 at maximum and the cell completely covered, the meter should read **infinity**. To determine whether the time-tender is generally on target, insert a normal-contrast negative into your enlarger carrier and project it onto the easel. The general idea is to check the known ratios of light intensities—by way of enlarger aperture stops—against corresponding readings on the meter.

Arbitrarily set R1 at about ¾-scale; set the enlarger at f / 5.6, and put about 12 in. between lens and easel. Locate the sensor so that the meter reads 5 seconds.

Leaving the sensor where it is, you should be able to note meter indications of 10 to 20 seconds—as read off the regular **ohms** scale, remember—for enlarger settings of f / 8 and f / 11. With the meter set initially at 15 seconds—everything else being the same—f / 8 and f / 11 will deflect the meter to 30 and 60 seconds.

This provides a preliminary check on the flat response of PC, and on whether the meter is tracking that response correctly. If there is any problem at this stage, the meter can be easily checked against known resistances. If the photocell is not behaving as it should, replacement is in order. Generally, the cell specified in the parts list is characterized

by an extremely high **dark** resistance, flat color-temperature response, and similarly flat response to light intensity. If you have to settle for a photocell substitution, this should be kept in mind.

The meter can be calibrated to indicate times for **integrated** light—using a ground-glass plate beneath the enlarger lens to scatter the light. It will also serve for **spot** measurements, in which negative contrast is taken into account. Using the time reading, with any "bright" area set at 1 second for an arbitrary reference, the darkest reading will be upscale. If it were 20 seconds, then your index number for this exposure would be 20. By recording these index numbers for successful applications of many different paper-contrast grades, you can make up your own table for what paper grade to use and when.

Almost all of the work has been done before you even begin the project in that a precision instrument and meter is already in your hands, in the form of the VTVM. The idea behind the time-tender is merely a match between the photocell and the meter's standardized scale. Assembling your own meter circuit gives the builder the added task of calibrating his own nonlinear scale.

Once a simple calibration procedure is followed through, the time-tender will help you see to it that you get perfect prints every time. Don't forget that the best results will be a partnership between your ingenuity and your equipment, probably not from an automatic answer man for every occasion.

PARTS LIST

J1, P1 — Miniature mating jack and plug
P2, 3 — Banana plugs, to match VTVM
P4 — Plug to match **common** input on VTVM
PC — Clairex CL74OHL photocell
R1 — 47K, ½-watt resistor
R2 — 5M, audio-taper potentiometer
S1 — SPST pushbutton switch (normally closed)
S2 — SPST pushbutton switch (normally open)

TWO-TRANSISTOR PHOTOVOLTAIC RELAY

With five components—solar cell, two transistors, a relay, and a 9V transistor-radio battery, you can have at your disposal nearly all of the photoelectric tricks that can be accomplished with a circuit of this type. The circuit (Fig. 4-13) uses two stages of amplification for increased sensitivity, is fast-reacting, and is deenergized at its low current-consumption stage when its photocell is "dark." This is the most useful design in photographic and darkroom applications, since it is usually a condition of light rather than shadow that is critical.

For the skeptic, the usefulness of this simplest of photoswitches will only be proved by putting it to work. With a clock in its control circuit, it becomes an automatic, after-the-fact timer for enlarger exposures. Used as the momentary action switch in a flash circuit, it becomes a sensitive slave-flash trigger. Put a buzzer across its relay contacts and make it a darkroom watchdog. Whatever you have in mind, the circuit's low cost and simplicity will make it well worth the effort.

HOW IT WORKS

The circuit uses a photovoltaic, or solar, cell to regulate relay action. In complete darkness, the solar cell is inactive, leaving the emitter of Q1 sufficiently negative in relation to its collector to make current flow very low. This negative voltage is also applied to the base of the second amplifying stage (Q2). Not enough current is able to flow through the relay coil to close its contacts. When light falls on the face of the solar cell, the cell becomes in essence a battery. It generates enough current to make the transistors supply operating power to the relay.

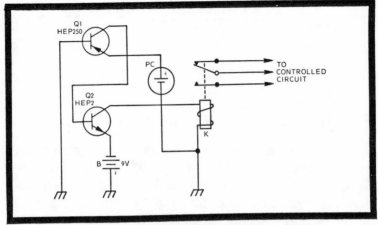

Fig. 4-13. Two-transistor photoelectric relay.

CONSTRUCTION

For experimental purposes, the circuit can easily be thrown together on a small piece of perfboard. It would also be simple to assemble it in a small metal box, using a multilug terminal strip to support the components. If the relay contacts will be controlling a high-voltage ac circuit, mount an ac socket on the circuit enclosure for the connections. For lower voltages, a barrier-type terminal strip will provide adequate versatility. The solar cell, of course, must be mounted in an exposed location.

USING IT

Determine your photoswitch's sensitivity by turning it on, then exposing the solar cell—mounted either remotely or in the circuit-enclosure surface—to pulses of light of varying duration and intensity. You will find the five-component circuit remarkably sensitive and fast-reacting. Finding a job for its switch-action to do is up to you.

PARTS LIST

B — 9V battery
K — SPDT relay, 5K coil (Potter & Brumfield LB-5)
PC— Photovoltaic cell (solar battery), Clairex B2M
Q1 — Motorola HEP 250 pnp transistor
Q2 — Motorola HEP 2 npn transistor

PHOTOSWITCH

Some of the very simplest of photoelectric circuits—types that will simply energize a relay when light intensity fluctuates up or down, for instance—are the prototypes of virtually all light-sensitive photographic equipment. Photocells affect in a predictable way the variables of the circuit into which it is connected. In fact, a photoelectric circuit—no matter how great its complexity—is designed to react rapidly and with sensitivity to the little photocell.

Most of these basic circuits—whether their photocells generate a voltage or resist one—act as high-gain amplifiers for the slightest telltale alteration of the condition of the sensor. Universally, the photocell's task is to "watch." The reaction of the circuit into which it is connected can be anything from the flip-flop of a relay to the slight deflection of a microammeter in a balanced circuit.

In these prototypes the hobbyist photographer can find many useful tools and spend dozens of enlightening hours throwing together, then tearing down, then recombining a handful of basic components into circuits with entirely different properties and capabilities.

HOW IT WORKS

The circuit you see in Fig. 4-14 is a two-stage amplifier whose bias and degree of conduction current depend directly on solar cell PC. In the dark, or at low light levels, the photocell applies a relatively low **reverse** voltage to the base of Q1, the first amplifier stage. This level is also reflected instantaneously on the base of Q2. Double the light intensity and the cell swings a fast and big stick. Depending on the settings of the two potentiometers in the photoswitch, relay response can be instantaneous or slightly delayed.

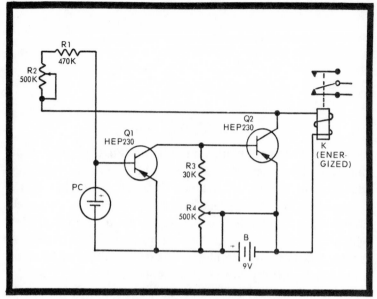
Fig. 4-14. Photoswitch (shown energized).

As the circuit is set up in this project, the relay is energized (its contacts are closed) when the photocell is dark. Current drain in this condition is quite high.

A moderately light condition for the photocell, on the other hand, creates a very low current consumption and the possibility of long-term operation. The action of the circuit in this situation would be to respond instantly to a **shadow**, energizing for the exact length of time that the cell is in darkness. A light condition again would bring the circuit back to its low-level, relaxed position.

Application in the darkroom could include an exposure meter—perhaps more sensitive than would be practical even for critical enlarger readings. Or how about a precision timer for enlarger exposures, in conjunction with an electric clock wired across the relay's open terminals?

As one-half of a "wireless" flasher, the flashes from a stroboscope can be either counterpointed or mimicked (at a moderately slow rate) with a fast-response incandescent bulb wired across either the closed or open contacts of the relay.

Or it can be used as a darkroom photoguard, set to open at the slightest hint of unwanted light, completing an alarm

TWO-TRANSISTOR PHOTOVOLTAIC RELAY

With five components—solar cell, two transistors, a relay, and a 9V transistor-radio battery, you can have at your disposal nearly all of the photoelectric tricks that can be accomplished with a circuit of this type. The circuit (Fig. 4-13) uses two stages of amplification for increased sensitivity, is fast-reacting, and is deenergized at its low current-consumption stage when its photocell is "dark." This is the most useful design in photographic and darkroom applications, since it is usually a condition of light rather than shadow that is critical.

For the skeptic, the usefulness of this simplest of photoswitches will only be proved by putting it to work. With a clock in its control circuit, it becomes an automatic, after-the-fact timer for enlarger exposures. Used as the momentary action switch in a flash circuit, it becomes a sensitive slave-flash trigger. Put a buzzer across its relay contacts and make it a darkroom watchdog. Whatever you have in mind, the circuit's low cost and simplicity will make it well worth the effort.

HOW IT WORKS

The circuit uses a photovoltaic, or solar, cell to regulate relay action. In complete darkness, the solar cell is inactive, leaving the emitter of Q1 sufficiently negative in relation to its collector to make current flow very low. This negative voltage is also applied to the base of the second amplifying stage (Q2). Not enough current is able to flow through the relay coil to close its contacts. When light falls on the face of the solar cell, the cell becomes in essence a battery. It generates enough current to make the transistors supply operating power to the relay.

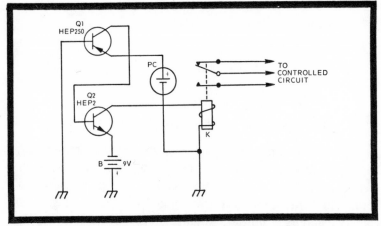

Fig. 4-13. Two-transistor photoelectric relay.

CONSTRUCTION

For experimental purposes, the circuit can easily be thrown together on a small piece of perfboard. It would also be simple to assemble it in a small metal box, using a multilug terminal strip to support the components. If the relay contacts will be controlling a high-voltage ac circuit, mount an ac socket on the circuit enclosure for the connections. For lower voltages, a barrier-type terminal strip will provide adequate versatility. The solar cell, of course, must be mounted in an exposed location.

USING IT

Determine your photoswitch's sensitivity by turning it on, then exposing the solar cell—mounted either remotely or in the circuit-enclosure surface—to pulses of light of varying duration and intensity. You will find the five-component circuit remarkably sensitive and fast-reacting. Finding a job for its switch-action to do is up to you.

PARTS LIST

B — 9V battery
K — SPDT relay, 5K coil (Potter & Brumfield LB-5)
PC— Photovoltaic cell (solar battery), Clairex B2M
Q1 — Motorola HEP 250 pnp transistor
Q2 — Motorola HEP 2 npn transistor

wired across its open terminals. It could be used as a light meter, carefully calibrated to sound off with a controlled circuit at known and preestablished light levels. Finally, it is usable as a momentary-action, normally open remote-control switch whose brief action initiates a predetermined sequence of events—whether it be a slave flash, semiautomatic slide projector, or automatic film advance in a remote, motorized camera. The last job mentioned, you probably noticed, takes advantage of the relay in a reverse hookup, working on the assumption of a normally energized relay and closed contacts.

It should be evident that even this photoelectric circuit and relay, designed to be triggered by shadow, presents almost too many options—nearly more than the truly creative darkroom worker and photographer could find time or attention for. If some difficult photographic problem presents itself, chances are you will find one solution, if not several, among the basic photoelectric circuits.

CONSTRUCTION

For the purposes of experimentation, all of the components in the photoswitch circuit can be easily thrown together on a small piece of perfboard, using flea clips or push-in terminal posts for good mechanical connections. The circuit can thus be easily torn down, rearranged, or replaced in part from extra components in your junkbox.

The compact size of the photoelectric circuit itself is complicated somewhat if the circuit's relay carries ac line-voltage in its switching function. On the surface of your metal enclosure (to house the circuit) will be mounted two potentiometers and possibly two ac sockets for the option of switching through either the **open** or **closed** condition of the relay.

Be certain to insulate the relay frame from the chassis, since the frame in many cases is in contact electrically with the armature.

This particular circuit (Fig. 4-14) should be chosen for its "normal" operating condition, which is during periods of high ambient light. For extended operations using the reverse configuration, battery life will fall discouragingly short of what it could be if the photoswitch's deenergized condition was made better use of.

Again, the amplifying action is basically the same in all of the photoelectric circuits. A solar cell generates a voltage when struck by light; it actively reverse-biases the transistors, the bias increasing as the light increases.

You can use a photoresistive cell (rather than a photovoltaic cell) as the bias element. Since the photoresistive cell is basically a resistor whose value is inversely proportional to light intensity, its effect on the amplifier is precisely opposite to the circuit just described: As light increases, the photoconductive cell's resistance decreases, biasing the amplifier in the **forward** direction. This makes it possible for a correctly designed circuit to be the **anticircuit** of the sensitive photoswitch.

PARTS LIST

B — 9V battery
K — SPDT relay, 5K coil (P & B LB-5)
PC — Photovoltaic cell (Clairex S1M)
Q1, 2 — Motorola HEP 230
R1 — 470K, ½-watt resistor
R2, 4 — 500K, linear-taper potentiometer
R3 — 30K, ½-watt resistor

PAPER SAVER

If a "paper safe" is not among your darkroom furniture, then you will certainly be interested in what this project has to offer. Many photographers—especially if they have to share their darkroom area with the washing machine and other basement activities—invest just a little time and even less money in the design and construction of a light-tight box to safely store unexposed photographic paper. Putting such a box together is usually one of the first steps to take in organizing even a little darkroom for efficient operation.

The paper safe itself, of course, is only the basis for the circuit presented in this project. Let it be enough to say that the shelved box can be made from almost any opaque material, but well seasoned wood is about the best. The space between the shelves, the number of shelves, and the overall dimensions of the box depend on the extent and nature of your work—on how many paper grades must be on hand, etc. The door of the cabinet latches firmly against a light-tight padding material, guaranteeing that not a glimmer, not a pinpoint of unsafe light will have a chance to give the photographer a box full of very expensive waste paper.

What the paper safe itself does not help you with is the accidental opening of the safe when the room light is on. This is when you begin wondering why you designed and put together the box in the first place. One good solution to those moments of forgetfulness is to automate the safe, having it take care of itself by turning unsafe room light off and a safelight on the instant the safe door begins to open. If you already have a safe, and have had one of these sad experiences, you may be interested in the simple and automatic control arrangement shown in Fig. 4-15A.

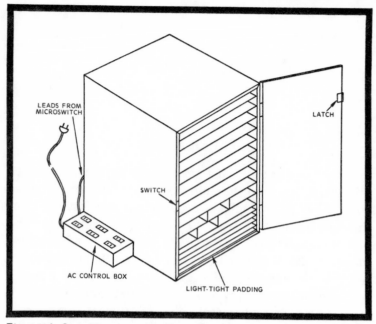

LEADS FROM
MICROSWITCH

LATCH

SWITCH

AC CONTROL BOX

LIGHT-TIGHT PADDING

Fig. 4-15A. One of the many possible designs for a paper safe. The control box at the cabinet's side and the microswitch comprise the electrical helper.

HOW IT WORKS

As can be seen from the schematic in Fig. 4-15B, no power is consumed that would not be consumed anyway. A normally open microswitch mounted on the doorframe selects which parallel circuit and which light or lights receive power. The key to the safe guard control is that only one circuit at a time can be completed. When the cabinet door is closed, the switch is also closed, completing the "white light" circuit. The slightest movement of the door away from the cabinet frame instantaneously breaks the room light circuit and just as quickly completes the safelight circuit.

CONSTRUCTION

The microswitch is mounted where it can be most sensitive to any change in the door's position. The modification of the frame needed to mount the switch is dictated by the different dimensions of personalized designs. The switch leads can be run easily along a shelf to a hole in the back of the box,

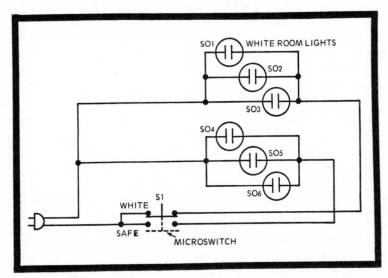

Fig. 4-15B. Paper-saver circuit wiring. As many sockets as necessary can be included.

but the hole subsequently must be carefully sealed again against any breach of light.

A small control box of the type shown with the safe in Fig. 4-15A is ideal for bringing as many lights as necessary under the control of the microswitch. Remember that the terminals and leads of the switch are hot. Whether it is better to collect the controlled lights near the paper cabinet or to run the high-voltage switch leads to a more convenient control point must be left up to the individual.

PARTS LIST

S1 — SPDT, side-mounting plunger switch
SO1, 2, 3, 4, 5, 6 — Chassis-mounting ac socket

Section 5

Advanced Projects

DARKROOM TIMER

Most of us try to anticipate not being able to tell a chair from a mudlark in the darkroom. Since most clocks don't talk, much less assist the photographer in any way towards determining the specific intervals that he requires for clean, crisp enlargements, he too often finds that he needs three hands to do the timing simultaneously with the control measures that might be necessary in a particular enlarging situation. The ideal, of course, would be to free himself from clock-watching and on-off distractions other than the initial setting of a timing device.

The specially designed timer described in this project is essentially a time-delay switch that—once set and turned on—will end exposure time by switching off the enlarger lamp at the end of the predetermined time interval. This period is continuously variable from 5 seconds to just over a full minute. The focus position of switch S2 makes quick and easy setup of the enlarger possible, turning on the enlarger lamp without engaging the timing portion of the circuit. This is especially convenient for single exposures of separate negatives. The accuracy and reliability of this device is no matter of conjecture or whim. The heart of the timer is a load for the resistor-capacitor (time-determining) components that control its firing. The timer tests out consistently at an accuracy of ±3 percent.

Since most enlargements need only 10 to 40-second exposures, the 5- and 60-second lower and upper ends of the timing range might seem to be unnecessarily versatile. Intervals of more than 40 seconds do tend to drastically increase the likelihood of blurring, while extremely short intervals

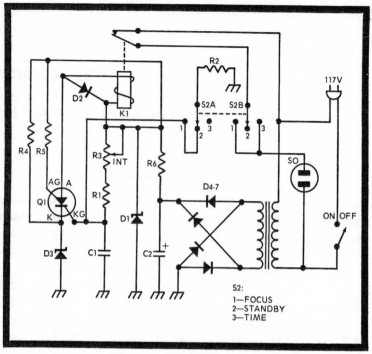

Fig. 5-1A. Darkroom timer.

make manipulation more difficult and tedious than it needs to be. But it is nice to have the full capability all the same.

The darkroom timer is somewhat sensitive to ambient temperature variations, but it is safe to assume that if the photographic developing process itself is going all right, then the timer will be in the range for which it was calibrated—a room temperature in the 68- to 70-degree range.

An increasingly common anomaly that tends to adversely affect circuits of this type is inadvertent line-voltage variation. In this circuit the effect of such variation is insignificant. Repeat accuracy is usually as valuable as absolute accuracy for the photographer. In this respect, the darkroom timer is excellent, having a repeatability factor of 0.97.

HOW IT WORKS

A silicon-controlled switch (Q1) is at the core of the circuit (Fig. 5-1A). When the cathode gate (KG) of this component is

positively charged, the switch is on. Conversely, when it is negative—or negative relative to the cathode terminal—the switch is off. As might be expected, relay K1 in the anode circuit of the semiconductor switch behaves accordingly, pulling in when on and deenergizing again when off. The relay's contacts act as a switch for an enlarger lamp (or for whatever device is connected across them).

The charge on the cathode gate depends directly on the charging time of the capacitor (C1) which in turn depends on the total resistance encountered in resistor R1 and potentiometer R3. Increasing the resistance will lengthen the charging time and extend the consequent action of the timing device as a whole. Because components are accurate only to their stated tolerance, initial adjustments of the value of R1 may be necessary to obtain the desired maximum and minimum time intervals.

The focus position of switch S2 facilitates adjustment of the enlarger for picture size, focus, and lens aperture; it essentially serves to disable the timing circuit, leaving the enlarger and safelight lamp connected. Standby is a condition in which both the lamp and the timer are disconnected. In the time position of this switch, the lamp is turned on and remains on for the time determined by the setting of timing potentiometer R3. In standby, the capacitor is allowed to discharge through R2, readying the circuit for operation again. Although the timer will not be harmed if it is left in the standby mode, switch S1 is incorporated to turn the circuit off when darkroom operations are over for the day.

CONSTRUCTION

Assemble the device using a 4 by 5 in. aluminum box about 3 in. deep. All the components will fit conveniently and neatly inside an enclosure of this size. One possible front panel layout is shown in Fig. 5-1B, indicating the position of the function selector, on-off switch, time-control potentiometer R3, and the ac socket at the timer's output. The power cord for the transformer is routed through a rubber-grommeted hole in the enclosure.

Relay K1 and the power transformer are grouped together at one end with the other power supply components mounted

Fig. 5-1B. One approach to front-panel layout of the darkroom timer.

and connected on a small piece of perfboard. This circuit board may be secured using the transformer's mounting hardware.

A small piece of glass-epoxy circuit-board material is recommended for the other components. The use of this type of board will help to resist moisture, which could otherwise impair the timing accuracy of the device. The glass-epoxy board is secured at the opposite end of the box from the transformer with angle brackets of the appropriate size.

Depending on the type of relay used, it may be a good idea to insulate it well from the metal chassis. The moving contact armature may be connected to the frame of the relay, causing it to be hot. After all the components have been assembled on the chassis, wire the circuit according to the schematic. You will want to label the control on the front panel with their appropriate functions.

USING IT

After double-checking the wiring and closing the chassis, plug the timer in, setting the selector switch S2 in the **focus** position. Plus a 100-watt lamp into the on-chassis ac receptacle

and turn the lamp on. Turn the timer on by setting switch S1 to time; the lamp will go on. To turn the lamp off, put S2 in standby.

The next step is to calibrate the timing function with a stopwatch or an electric clock that has a sweep second hand. Set R3 at its maximum resistance, fully clockwise. Turn S2 to the time position, and measure the time until the lamp goes off. It should be 65 to 70 seconds. If the interval is shorter than this, slightly increase the value of R3.

Once this maximum interval has been correctly established, turn R3 to its minimum resistance position. At this setting, time the interval again. The period should clock in somewhere around 4 to 5 seconds. If its doesn't, another adjustment in the fixed component values of the circuit will have to be made—this time in R1. Decrease the value of this resistor to shorten the timing interval. Changing the value of R1 will have no effect on the maximum time that has already been set.

The final step is to calibrate the intermediate settings of R3, using the same clock used in obtaining the maximum and minimum times. A good procedure is to first establish the 10-second intervals by making pin pricks on the enclosure around the knob on R3. Then go to the 5-second intervals. This degree of calibration is apt to be sufficient for uses most photographers will find for the device. If you have the patience, make the one-second markings as well. Use decals or dry transfer numbers for the primary markings. If the knob is taken off to make these permanent markings, be certain to replace it with the exact orientation it had at the outset.

The darkroom timer is now ready to become a permanent and useful piece of equipment in your darkroom. Being self-controlling, it will prove invaluable as a third hand in your darkroom processes. As mentioned earlier, the repeat accuracy of this timer is extraordinarily good. If you are using the test-strip method for determining time and paper grade, it is more important to depend on the accurate repetition of an interval than it is to be right-on with an external absolute reference. This timer does the trick.

PARTS LIST

C1	— 33 uF, 20V tantulum
C2	— 200 uF, 25V electrolytic
D1	— 1N758 zener diode
D2, 4, 5, 6, 7	— any diode with PIV of 25V or more
D3	— 1N4730 zener diode
K1	— SPDT relay, 2.5K coil (Sigma 4F-2500S-SIL)
Q1	— 3N84 silicon-controlled switch
R1	— 390K, ½-watt resistor
R2	— 100 ohm, ½-watt resistor
R3	— 5M, linear-taper potentiometer
R4	— 3.9K, ½-watt resistor
R5	— 100K, ½-watt resistor
R6	— 180-ohm, ½-watt resistor
S1	— SPST switch
S2	— 2-pole, 3-position rotary switch (nonshort)
SO1, 2	— Chassis-mounting ac receptacle
T1	— Power transformer; 117V pri, 12V sec.

ELECTRONIC DARKROOM THERMOMETER

Stunning prints—homemade and developed—are the result of a thorough knowledge of darkroom procedure—of photographic solutions, times, and temperatures. Buying or constructing an accurate timer for enlarging or printing won't do anybody much good unless he has a means to measure with at least a fair degree of accuracy the temperature of his developing solutions.

Even if room temperature has been brought into the usual range of 68 to 70 degrees, the average photographer does not have the time to let his solutions sit for long periods of time after mixing with tap water until he is certain they have stabilized to room temperature.

As you probably are painfully aware, one or two degrees variance in your developing solution must be compensated for in the timing half of the procedure. Temperatures for color printing are even more crucial.

This can become a real pain in the neck if you're working in the dark or under a dim safelight; and it's easy to forget to make periodic temperature checks if you are involved in a complex developing process. The electronic darkroom thermometer described in this project will provide a **continuous** check on the temperature of any liquid, and produces an audible alarm whenever the temperature deviates above or below a preset figure. Now, doesn't that sound like something you can use?

The ideal darkroom thermometer is reliable, readable, sensitive, and fast-reacting. A device with all of these qualities and more is the electronic thermometer described in this chapter. Totally avoiding the temperature-expansion characteristics of the conventional mercury thermometer, this one incorporates a **thermistor**, a temperature-sensitive resistor that regulates the action of three relays.

Fig. 5-2A. Electronic darkroom thermometer.

HOW IT WORKS

The voltage from battery B1 is applied to the resistance bridge formed by R1, R2, R3, R4, and R6 (Fig. 5-2A). When this resistance bridge is balanced (by adjusting potentiometer R3), a zero voltage appears at the base of transistor Q1. With the lack of a forward biasing voltage on this stage, the other transistor (Q2) may be forward-biased through resistor R7. This allows current to flow in the collector circuit of Q2, thus energizing relay K3.

Lowering the setting of R3 results in a greater negative voltage on the base of Q1, which begins to offset the forward bias and collector current flowing through stage Q2. Turning the shaft of R3 far enough counterclockwise will cut off Q2 and the deenergizing relay K3. The exact setting of R3 at which this will happen depends on the resistance of R1 and R6. Since R1 is a thermistor, whose resistance changes with temperature, R3 can be calibrated with reference to temperature. The signal for each temperature "balance" will be the action of the relay.

With a particular temperature setting, K3 will open and the bridge will be balanced. As the temperature rises, however, the point will be reached at which so little current passes through Q1 that relay K3 closes, applying voltage from B2 to relays K1 and K2. The charging action of capacitor C1 causes a periodic opening and closing action in K1, clicking about once per second. This signals a dangerous temperature rise. The relay will continue its warning until K3 opens again, meaning that the temperature of the liquid around the thermistor and its resistance are back to the correct levels.

A change of a fraction of a degree is enough to open and close K3. To guarantee high sensitivity to slight elevations and drops in temperature, relay K2 has been inserted in the emitter circuit of Q2; this is because the amount of current needed to close relay K3 is greater than that needed to hold it closed. Removing the ground in the emitter of Q2 reduces the current flowing through the coil of relay K3 to a better approximation of the initial level. Consequently, a smaller change in temperature is sufficient to open it again. The same fraction-of-a-degree change is then all that is required for the relay's opening and closing.

CONSTRUCTION

Be careful with the thermistor. In the form in which you will purchase it, it is mounted on the end of a half-inch length of glass tubing, with its two leads emerging from the other end of the tube, as pictured in Fig. 5-2B.

To fashion a durable probe, use a 6 in. length of quarter-inch polystyrene tubing. The insulated wires running from the probe to the circuit enclosure can be any convenient length, and should be twisted together. At the thermistor end, one lead must be covered with sleeving to prevent shorting. Both leads of the thermistor are then soldered to connecting wires.

The wires are to be threaded through the polystyrene tube. Tug at the wires until only the tip of the thermistor is exposed at the end. A small amount of polystyrene cement applied to the open end of the probe will provide moisture protection. It is also not a bad idea to use the cement liberally on the internal probe connections to make the assembly even more waterproof. Stranded wire should be used for the connecting leads,

Fig. 5-2B. Enclose the probe-type thermistor in a length of polystyrene tube for convenient handling and electrical protection.

since they have the flexibility to withstand bending and handling more reliably than solid wire.

The rest of the components are mounted on perforated circuit board and housed in a small aluminum enclosure. The probe leads can be connected directly into the circuit, or provision can be made to make the probe detachable with a phono plug and jack. This arrangement would enable you to put the probe in a safe place when it is not in use. The jack should be connected into the circuit as shown in Fig. 5-2C. Potentiometer R3 and switch S1 are mounted on the front panel of the small box.

If you are working in a situation where the ticking sound of the periodically switching relay is not loud enough, it will be necessary to make a slight modification and addition to the basic circuit. Ground the bottom end of K1's coil and eliminate capacitor C2. This enables the relay contacts to control an external noisemaker, like a bell or buzzer.

Fig. 5-2C. A phono plug and jack will make the probe detachable from the circuit enclosure.

USING IT

After checking everything, reduce the setting of poten-tiometer R10 to its minimum. Switch in the batteries with S1, turn potentiometer R3 fully counterclockwise, then advance R3 slowly. If the temperature in the room is somewhere between 70 and 75 degrees, you will locate a setting of R3 that will close relays K3 and K2, and will initiate the clicking of relay K1. Then turn R3 **ever so slightly counterclockwise** and adjust R10 until the clicking stops.

The resistance of R10 is critical for the correct operation of the circuit. Too high a setting will result in the sporadic opening and closing of K3, while too low a setting will result in a marked difference between the **on** and the **off** settings of main control potentiometer R3. Once this procedure has been completed, the actual calibration can begin.

The calibration materials consist of an accurate photographic thermometer, a suitable container, a stirring rod, a supply of warm water, and some ice cubes. The paper dial plate that will be used on the device should be taped temporarily under the knob of R3.

Partially fill the container with 70-degree water, place the probe in the liquid, and turn R3 fully counterclockwise. While stirring the contents, slowly add warm water until K1 begins to click. Now, slip an ice cube into the water until the relay just stops clicking. Stir vigorously, then wait a minute until the water stops moving. Advance R3 only far enough to start the relay action. Read the **standard** thermometer and make a mark opposite the pointer on R3's dial plate.

Put the ice cube back in the water until the temperature drops one degree, then advance R3 until the clicking begins again and make another marking. By following this procedure through until R3 can be advanced no further, you will have 1-degree calibrations from 80 to approximately 55 degrees. Keep in mind that the thermistor reacts much faster than the thermometer being used to calibrate it. Give the thermometer enough time to respond before comparing it with the setting of R3.

Temperature sensitivity variation of the entire device should be significant under normal darkroom conditions. The thermistor's sensitivity, on the other hand, will surprise even

the most skeptical. If fluctuation within one degree or so is satisfactory for your purposes, the circuit can be modified into a slightly more modest version of the original. This is done by grounding the bottom end of R9 and entirely omitting K2, R10, and R11. The response of K3 will not be quite so balanced in opening and closing, but the overall circuit operation remains the same.

As the circuit is designed, it registers increases, rather than decreases, in temperature. This is generally the most useful, since developing solutions tend to become warmer than they should. For the warmer temperatures required in some color developing processes, however, you may want to be aware of decreases in temperatures. To accomplish this, merely switch the wires on the two terminals of relay K2.

In addition, an even wider range of temperatures can be monitored by changing the values of R2, R3, and R4. Generally higher temperatures will be measured by increasing the value of R4 and decreasing the value of R2. Whatever changes are made, the overall resistance of the bridge should remain at about 14K.

PARTS LIST

B1	— 9V battery
B2	— 30V battery
C1	— 100 uF, 25V electrolytic
C2	— 5 uF, 25V electrolytic
K1, 2, 3	— SPDT relay (Sigma 11F9000-G-SIL)
Q1, 2	— 2N321
R1	— Thermistor, 4K (Fenwall GB34P2)
R2	— 4.3K, ½-watt resistor
R3, 10	— 2.5K, linear-taper potentiometer
R4, 6	— 9.1K, ½-watt resistor
R5	— 6.8K, ½-watt resistor
R7	— 62K, ½-watt resistor
R8	— 75K, ½-watt resistor
R9	— 1.1K, ½-watt resistor
R11	— 2.7K, ½-watt resistor
S1	— DPST switch

PHOTO TIME-DELAY CIRCUIT

Being both the photographer and the subject of a home photographic session is one of the "essentials" in a photographer's bag of tricks. It is almost a welcome relief from the kids and other animate targets that never seem to sit still for more than an average of about 5 seconds. And how better to control the subject than to actually **be** the subject?

Many currently available cameras feature a short, motorized time-delay activation. The considerably longer delay of 2 minutes is available from the simple circuit described in this project. For use specifically with a camera, however, the camera must be fitted with an electrically triggered solenoid-type shutter release—like the device described in Section 4 (Fig. 4-8A)—or be of a type that can directly accommodate the electrical output of a triggering device.

Much simpler applications for a time-delay switch in the darkroom should be readily apparent. It can be used to automatically turn on an enlarger, room lights, or an audible alarm after a given interval.

This circuit can handle a load of up to 240 watts and features totally electronic operation; it has no moving parts to interfere with the precision of its electronic components or detract from its ability to react instantaneously to the signal of its own internal timing circuit. The available delay is as long as 2 minutes or as short as 5 seconds, and is continuously variable through this range.

HOW IT WORKS

The schematic for the circuit is shown in Fig. 5-3. The timing action of the circuit depends on the value of capacitor C2 and on how long it takes for this component to charge to the

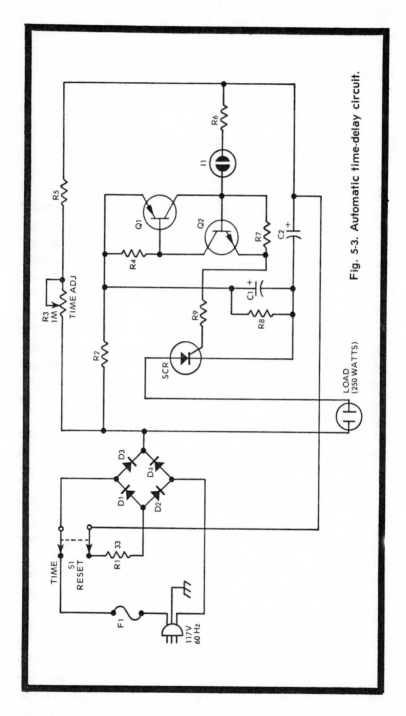

Fig. 5-3. Automatic time-delay circuit.

voltage necessary to turn on neon lamp I1. This capacitor charges through series-connected resistors R1 and R2. The firing of the lamp, in turn, turns on the regenerative switch formed by transistors Q1 and Q2. This portion of the circuit also has a time control in potentiometer R3.

When the time-delay action is initiated by turning switch S1 to time, the full-wave rectified current from the bridge rectifier (D1-4) charges capacitor C1. This charging potential is kept low by voltage-dividing resistors R2 and R8.

Timing capacitor C2 also begins to charge. When its potential reaches about 75V, neon I1 conducts and triggers the switch formed by the transistors. When this happens, enough current is applied to the gate of the SCR to cause it, in turn, to conduct. The circuit across the load is thus completed, continuing to supply current across the terminals of socket SO1 until switch S1 is turned off. Capacitor C2 charges to ground and the circuit is ready for another time-delay action.

CONSTRUCTION

Component layout is not critical. The main thing to keep in mind is to insulate the entire circuit from its enclosure. A small 3 by 4 by 5 in. aluminum box is large enough to conveniently house all the components. Two or three terminal strips secured to the enclosure will be sufficient for all connections other than the fuse holder, switch, potentiometer, and socket for connecting the external load.

Any long leads or connections that might be in danger of shorting to the chassis or to each other must be made with insulated connecting wire. If only one specific application is anticipated for the unit, connections to the controlled device can be made directly into the circuit through a rubber-grommeted hole in the enclosure. The grounded ac plug shown in the schematic will be the ideal ground-fault protection.

USING IT

The potentiometer is calibrated for different delay times. This can be easily accomplished once the controlled device is connected in the circuit. The interval from the instant S1 is thrown into its time position to the instant power is supplied to the load can be varied from approximately 5 seconds to 2

minutes, depending on the setting of R3. The off position of S1 is also the timer's reset condition. A few seconds and the time delay is ready to go again.

The range of the timer can be increased to 5 minutes or even greater by increasing the value of C2. This capacitor is subject to aging and may change its value over an extended period. If this happens, it is easy to recalibrate the circuit. The precision of the circuit is extraordinarily good in repeatability and should completely fulfill the requirements of the home photographic buff.

To make the circuit photoelectric—initiating its delay control action with a source of light instead of the flip of a switch—one of the photoelectric switches covered in this book may be substituted for mechanical switch S1. Don't hesitate to experiment with such combinations if you come up with an application that requires that little "something extra."

PARTS LIST

C1	— 50 uF, 25V electrolytic
C2	— 60 uF, 150V electrolytic
D1-4	— Motorola HEP 156, silicon diodes
F1	— 3A fuse, 125V
I1	— NE-83 neon lamp
Q1	— Motorola HEP 254
Q2	— Motorola HEP 50
R1	— 33-ohm, ½-watt resistor
R2	— 3K, 8-watt resistor (±5 percent)
R3	— 1M, 2-watt potentiometer
R4	— 150-ohm, ½-watt resistor
R5	— 47K, ½-watt resistor
R6	— 10K, ½-watt resistor
R7	— 470-ohm, ½-watt resistor
R8	— 180-ohm, ½-watt resistor
R9	— 100-ohm, ½-watt resistor
S1	— DPDT switch
SCR	— 2N3228

INEXPENSIVE STROBOSCOPE

One of the most useful devices in experimental photography is the stroboscope. It can create the eerie, repetitive **kinetic** images on a single exposure, stopping action at intervals that depend on its rate of flashing. The small stroboscope described in this project is versatile enough to cover just about any application, but has a maximum speed well below the 9 pps rate considered dangerous to the human eye. The circuit presented here is about as simple as you can get and yet have something that is useful to the photographer. The circuit shown in Fig. 5-4A gets into the high-power range with a full-fledged flash tube capable of high short-duration intensities.

HOW IT WORKS

When the stroboscope is turned on, capacitor C1 begins charging through resistors R1 and R2. The voltage is also

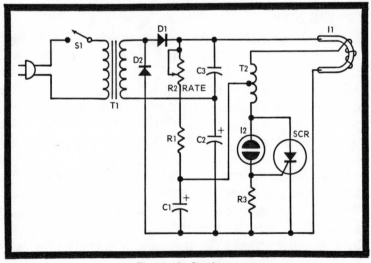

Fig. 5-4A. Stroboscope.

Fig. 5-4B. The completed stroboscope.

coupled to the SCR through part of trigger transformer T2. As enough potential reaches the top of neon bulb I2, the bulb fires and applies a positive potential to the gate of the SCR. This component then triggers, allowing capacitor C1 to discharge through T2, which generates a high-voltage pulse and applies it to the trigger electrode of the flash tube. The trigger pulse is all that is required to cause a flash of brilliant white light from the tube. Since C1 is in a discharged condition, the whole process is ready to begin again. The interval at which it repeats itself depends on the setting of potentiometer R2.

CONSTRUCTION

You can assemble all the components—including the flash tube—on a single piece of insulated circuit board. If the tube is mounted on the board, of course, some sort of transparent enclosure will be necessary. This is not very suitable for the directional flash applications of the photographer. You will probably want to fashion a small reflector and mount it on the top or in the side of the circuit enclosure, with the small flash tube mounted at its center. (See Fig. 5-4B.)

The flash tube has three leads, one at each end of the U-tube and one connected to the tube's trigger electrode. Solder a short length of thin wire to this electrode and wrap it around the center of the tube several times, being sure that the lead is well isolated from the other two leads. The extra wrappings of this wire increases the effectiveness of the

electrode. If the flash tube is mounted at any distance from the other circuit components, the leads should be carefully insulated. It is also important to get the polarity of the T2 connections correct, as one lead has a special trigger pulse function. Potentiometer R2, switch S1, and the flash tube itself are the only components that need to be accessible and mounted on the outside of the enclosure.

USING IT

A 3A fuse can be used to protect the circuit until you are certain it is working correctly. After the stroboscope has been on, never touch it until the capacitors have been discharged. Adjusting the setting of R2 will cause it to flash at different rates, up to maximum of approximately 7 or 8 flashes per second. The circuit has a significant power rating, and most of the power must be dissipated by the flash tube. There must consequently be provisions for heat transfer if the tube is to be enclosed.

PARTS LIST

C1, 2	— 20 uF, 250V electrolytic
C3	— 4 uF, 150V electrolytic
D1, 2	— Motorola HEP 156, silicon diodes
I2	— NE-2 neon lamp
I1	— Flash tube (Amglo U35T)
R1	— 150K, ½-watt resistor
R2	— 1M, linear-taper potentiometer
R3	— 120-ohm, ½-watt resistor
S1	— SPST switch
T1	— Power transformer (Stancor P-6425)
T2	— Photoflash trigger coil (Stancor P-6426)
SCR	— 2N2325

DARKROOM PHOTOGUARD

That minor light leak that will ruin an enlarger exposure could come from the safelight filter slipping out of position, from the darkroom door being cracked open slightly, from opening your paper safe by accident while the printing light is on, or any one of a dozen other such disasters. Nobody likes to waste material or be caught off guard by a sneaky light leak that, even at best, causes costly fogging of virgin photosensitive materials.

What is needed is a sensitive photoelectric alarm that will produce a warning if the intensity of ambient light gets into an unsafe range. This project is just such a device, and can be used to operate a warning bell or other audible alarm, and contains the option of having its action turn off electrical darkroom devices automatically, much faster than the photographer himself could react to shut down his operation if he has any intention of saving whatever is in progress.

HOW IT WORKS

As with many devices of this type, the circuit (Fig. 5-5A) is built around a silicon controlled rectifier. Whenever the SCR is triggered with a voltage pulse fed to its gate, current flows from the dc supply through the relay coil to pull in the relay contacts. The power supply consists of transformer T1, the rectifier bridge, filter capacitor C1, and resistor R3. The relay remains energized once the SCR has been triggered until main switch S1 is put in its off position. When the relay is released, the SCR goes into its original condition and the device is ready for another light-detection operation.

Relay K1 has a double set of contacts. One set is used to control a buzzer and neon bulb I2 for both an audible and a visible monitoring alarm. The other set opens as the circuit is triggered, effectively disconnecting the external device connected across the contacts.

The rest of the circuit performs a triggering function. The determining factor is the charge across capacitor C2. The moment this charge surpasses the breakdown potential of diode D6, the capacitor releases a surge of current through the diode onto the gate of the SCR, allowing it to conduct and energize the relay. The charge on C2 depends on the resistance of PC1 and potentiometer R4. As a certain level of light falls on the cell, its resistance is reduced enough to cause the charge on C2 to rise sufficiently to initiate the trigger action. The sensitivity of the device to light is controlled with R4, which is set at safe light levels just below the trigger voltage of D2; any dangerous increase in light will cause the appropriate alerting response.

CONSTRUCTION

The entire assembly will fit—with room to spare—inside a 3 by 5 by 7 in. aluminum box. Since there are several high-voltage connections to be made, having a little extra room is not a bad idea. Most of the components for the trigger, SCR, and relay circuits can be mounted on a small piece of perf-board. Terminals or a socket for the remote relay control are mounted through the top of the box.

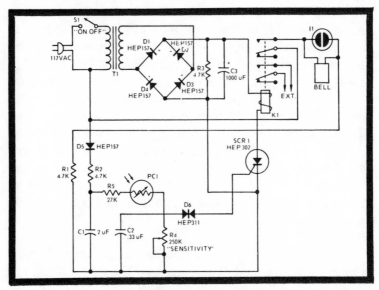

Fig. 5-5A. Darkroom photoguard.

Component layout is not critical, but it is preferable to group the high-voltage connections together. A small hole must be drilled in the chassis to support the photocell. Cement its rim to the inside of the box to hold it in place. The neon bulb in the relay circuit is optional. It goes on along with whatever audible alarm you have connected. One conceivable problem is that the neon bulb might emit too much unsafe light of its own in the darkroom situation. It's handy in helping to locate the power switch of the alarm in the otherwise complete darkness. The bulb can also be connected directly in the power lead to serve as a continuous pilot light.

It is safest to make the photocell sensitive to light coming from all directions rather just than from locations directly in front of the cell. This can be accomplished by shielding the cell with something white and translucent, like a Ping-Pong ball. This diffuser will react to a very small amount of light.

USING IT

Calibrating the darkroom photoguard is best done by a trial-and-error procedure that will reflect the lighting conditions in your own situation. Once you establish the correct ambient light levels—which will probably be limited to nothing more than a safelight—turn the alarm switch on and advance potentiometer R4 until the alarm is triggered. Then turn the alarm off and back off R4 a little bit. If, when it is turned on again, the alarm is triggered, repeat the procedure. The result, when the alarm is not triggered, will be a very high sensitivity to the least bit of light that the photocell receives.

After using it for a while, R5 may have to be readjusted for the circuit to retain its highest sensitivity. Be careful not to set it too low, or the circuit will not respond even to danger levels.

Many other possibilities are open to the builder of this device—and not only in light-sensitive applications. An external switch may be connected as shown in Fig. 5-5B; here, the photocell is disabled by covering it with a light-blocking material. Opening this external switch will cause the alarm to go off.

Instead of covering the photocell, provision can be made to switch it out of the circuit, as shown in Fig. 5-5C. A dual-circuit audio jack is best for the connection into the circuit, as

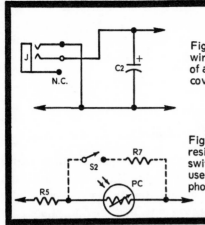

Fig. 5-5B. Diagram showing the wiring of a jack to permit the use of an external sensor. Photocell is covered with opaque material.

Fig. 5-5C. Wire a switch and resistor as shown. Close the switch when external sensor is in use to eliminate need to cover photocell.

shown in the diagram. A 100K resistor is then connected to replace the photocell if you anticipate using the device for some of the other alternative applications. The external switch could be located on a door frame, could be a thermostat to make the darkroom photoguard a fire alarm, etc. Anything that will break a connection can act as the external stimulus for the relay to close, setting off the alarm. When you are off duty in the darkroom, some of these other uses might prove very useful. Don't hesitate to try them.

PARTS LIST

C1 — 2 uF, 15V capacitor
C2 — 0.33 uF, 15V capacitor
C3 — 1000 uF, 15V electrolytic
D1-4 — Motorola HEP 157 silicon diodes
D6 — Motorola HEP 311 diac (bidirectional diode)
I1 — Neon pilot lamp assembly with red lens (Leecraft 32-2211)
K1 — DPDT relay, 10A contacts, 6V coil (Guardian 2006D coil, 200M2 switch assembly)
PC — Clairex CL5M3 photocell
R1-3 — 4.7K, ½-watt resistor
R4 — 250K, linear-taper potentiometer
R5 — 27K, ½-watt resistor
R6,7 — 100K, ½-watt resistor (2nd one optionl)
S1, 2 — SPST switch (2nd one optional)
SCR — Motorola HEP 320
T1 — Filament transformer (Stancor P-6465)
J — Optional jack (accessory)

TIMING RELAY

This project is a highly reliable general-purpose timer that you will find useful in the darkroom. It can be used to turn off an enlarger lamp after a specified interval, and is also adaptable to any electrically controlled switch, flash, or general lighting circuit. The circuit is especially useful in exacting color work with photographic projection printing. The timer can free the photographer for other darkroom work and will provide accurate repetitive accuracy for uniformity of exposure from the first print to the last.

The timer has two ranges—0.6 to 6 seconds, and 6 to 60 seconds—each of which depends on a different timing capacitor. The addition of this extra capacitor, and the subsequent general versatility required of the other circuit components, do not in any way affect the accuracy of the timer.

The relay action controls the power to an ac socket. Anything plugged into that outlet will be regulated with the on-off action of the relay. This external electrical device can be made to turn on or turn off after a given amount of time, which is predetermined with the setting of the timer. If direct control of your darkroom equipment is not needed or wanted, than a 117V noisemaker might be connected to the relay contacts to signal the end of the period needed for a particular operation.

HOW IT WORKS

The heart of the timer, the schematic for which is shown in Fig. 5-6A, is field-effect transistor Q1. When DPDT switch S2 is in its reset position, the gate of this transistor is at ground potential. The effect of any positive potential at this gate is to reverse-bias it, meaning that the voltage at this gate has to rise sufficiently before Q1 will conduct. Separate biases for the

two timing ranges are switched into the circuit in the form of trimmer potentiometers R5 and R7, with timing capacitors C3 and C2. These are necessarily different and adjustable for the two time ranges.

The time it takes the gate of Q1 to reach the potential necessary for conduction depends on the charging circuit. The charge builds up on C2 or C3 through resistors R1 and R2. Since the value of R1 is variable, this charging time may be varied to any degree within the overall range of either of the charging circuits.

When Q1 begins to conduct, so do transistors Q2 and Q3. The load in the collector circuit of Q3 is the parallel combination of pilot lamp I1 and the coil of relay K1. Consequently, as the entire circuit begins to conduct, the lamp lights and the relay is energized, closing its contacts and effective the external electrical connection.

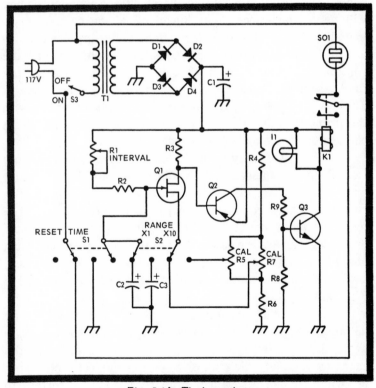

Fig. 5-6A. Timing relay.

As the circuit stands now, the ratio of values R2 to R1 sets the relationship (10:1) between the two timing ranges. These values can be changed to alter the maximum and minimum times available from the circuit action; but it should be kept in mind that the relationship of the scales will be altered in respect to each other. Trial-and-error testing—if you wish to extend or limit the overall range of the timer—will determine the different values that will again guarantee the 10:1 ratio for the convenient use of a single calibration scale for both ranges. The ranges available from the part values given in the parts list should be sufficient for the timer's darkroom applications.

CONSTRUCTION

A 3 by 5 by 7 in. aluminum chassis is just about perfect for the construction of the timing relay. Cutting a piece of perfboard to a size slightly smaller than the front panel of the box will permit one-piece mounting of all of the components—including the switch and controls. Holes of the appropriate size are drilled through both the board and the chassis, and the controls are mounted through both of these surfaces in the final assembly. Component layout, in general, is not critical. The only high-voltage precautions that must be taken are with the primary connections to the transformer and the direct connection to the ac outlet socket.

The frame of relay K1 will probably have to be insulated from the metal enclosure. This is because the relay armature and the frame are electrically common. If the armature is switching a hot circuit, the frame is also apt to be hot. Three toggle switches are mounted on the front panel of the unit. Switch S3 connects the power, S1 initiates the timing sequence, and S2 selects range. The outlet socket, for convenience, should be mounted on the side of the enclosure, as pictured in Fig. 5-6B.

Use heavy-duty insulated connecting wire for all the ac voltage hookups. Be careful in soldering the semiconductors to avoid damage from overheating. Get the polarity of the capacitors—all of which are electrolytic—correct. The wiring of switch S2 can also get a little confusing. Be certain to

associate the right potentiometer with the right timing capacitor. Though no significant damage will result from a mistake, the operation of the timer will be uncertain at best. Remember also to be polarity-minded when connecting the diodes in the rectifier bridge. Being careful right from the start will give that tremendously satisfying result of having something work the first time.

USING IT

Plug the timing relay in, being certain S3 is in the off position. Set S1 to **reset** and range selector S2 for 0.6 to 60 seconds. Now there is a simple and easy way to calibrate the timer, since the interval that it is designed to time is the **on** function of whatever electrical device is connected across the relay contacts. Plug an electric clock with a sweep **second** hand into SO1. Reading the clock from the moment the S2 is set to **time**, to the moment the clock stops provides a reasonably accurate measurement for different settings of potentiometer R1.

Trimmer potentiometers R5 and R7 are set to approximately midrange. Precise calibration is accomplished by adjusting R7 in the 6-second range and R5 in the 60-second range. With R1 at its maximum setting in each range, adjust R7 and R5 so that the timing action equals 6 and 60 seconds, respectively. The clock provides a direct indication of what the timer is doing. Once this procedure is complete, a single scale will serve both ranges.

Fig. 5-6B. The completed timing relay.

As you have probably noticed, neon lamp I1 provides a monitor for when the relay has been energized and for how long. The lamp goes out when the timing relay's work is done.

One question that may come to mind is whether the light from the lamp will increase ambient light levels beyond a safe intensity. In the instance of its use with an enlarger lamp, the pilot light will be on only when the enlarger is on, and should thus cause no problems. Facing the timer away from the exposure will put an end to any problems that do occur.

As mentioned earlier, the range of the timing relay can be affected by deliberately changing component values, most noticeably the two timing capacitors, C2 and C3. Keep two factors in mind, however, if you are going to change either of these values. First, the shorter time of the relay, which far exceeds the reacting time of the electronic components themselves. Second, the longest time will be limited by the leakage rate of the timing capacitor. The maximum interval of a timer of this type is limited by this factor to several minutes. If longer times are desired, the problem can be partially solved by using the more expensive tantalum capacitor, which has a lower leakage rate.

Setting S1 back to its reset position allows the appropriate timing capacitor to discharge directly to ground. The circuit is then immediately ready for a repeat performance. In the enlarger application, preliminary focusing and other adjustments must be made by turning the timer on. There is no provision for leaving the lamp on indefinitely, but this should present no great problem. The adjustments that need to be made will no doubt fall within the limits of the timer's range.

PARTS LIST

C1 — 1000 uF, 15V electrolytic
C2 — 2 uF, 25V electrolytic
C3 — 20 uF, 25V electrolytic
D1-4 — Motorola HEP 154 silicon diodes
I1 — Type 1815 pilot lamp
K1 — SPDT relay, 335-ohm coil (P & B RS5D)
Q1 — Motorola HEP 801 field-effect transistor

Q2 — Motorola HEP 52 pnp transistor
Q3 — GE 20 general-purpose npn transistor
R1 — 5M, linear-taper potentiometer
R2 — 560K, ½-watt resistor
R3 — 6.8K, ½-watt resistor
R4, 6 — 470-ohm, ½-watt resistor
R5, 7 — 350-ohm, linear-taper potentiometer
R8 — 2.2K, ½-watt resistor
R9 — 120-ohm, ½-watt resistor
S1, 2 — DPDT switch
SO1 — Chassis-mounting ac receptacle
T1 — Filament transformer (Stancor P-6465)

SHUTTER ANALYZER

Shutter speed—one of the least tangible of the controls that a photographer has over his results—is all too often the undetectable source of trouble he has in obtaining correct exposures. If actual shutter speed is slower than your camera setting would indicate, then all the other settings will also be out in right field as far as the desired result is concerned. Discrepancies between your shutter setting and actual speed can be caused by lower temperatures than mechanisms find tolerable or by lubrication that you have inadvertently allowed to dry out, among others. If you are having trouble with your results, and are hard-pressed for a solution after giving other control measures a careful check, then having a means to check up on shutter speed may provide the answer.

The shutter analyzer is not one of those exotic gadgets that tend to collect dust after the novelty has worn off. You will find many occasions to make use of the shutter analyzer—much more than you might anticipate. The device has the advantages of relatively low cost and is not particularly difficult to construct.

The analyzer provides a direct reading for speeds from 0.001 to 1 second. After initial calibration, it will prove to be a useful and reliable photographic tool, enabling you to sidestep those camera shop fees for "just a checkup." If repair or lubrication is required, of course, don't hesitate to seek out a professional for the job, since precision work in the home workshop seems more often to backfire than to have a happy ending.

HOW IT WORKS

The schematic for the shutter analyzer is shown in Fig. 5-7A. The circuit is basically a peak-reading voltmeter, mean-

ing that its meter will maintain a reading until a reset button is pressed. Meter deflection is the result of the condition of phototransistor Q3. The voltage generated by exposing this photosensitive component to light depends on both the intensity and duration of that light. Since all intensities for the purposes of testing shutter speed will be the same, it is only the duration of the exposure that is of consequence. Calibration with a shutter of known speed initially establishes precise speeds for subsequent use of the meter.

CONSTRUCTION

The circuit features a metal-oxide FET, or MOSFET. This is a very peculiar but highly capable breed of semiconductor. More delicate than most, it requires a lot of care in handling and in installation. Even a static charge accumulated on the experimenter's body can be enough to damage the com-

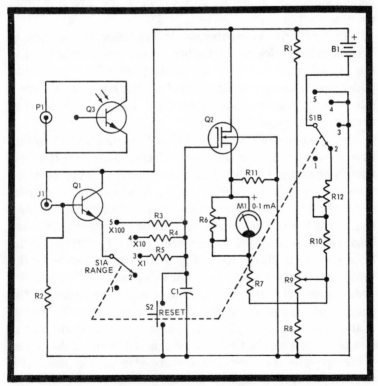

Fig. 5-7A. Shutter analyzer.

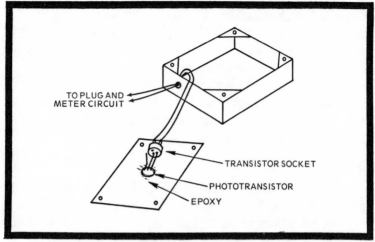

TO PLUG AND
METER CIRCUIT

TRANSISTOR SOCKET

PHOTOTRANSISTOR

EPOXY

Fig. 5-7B. Constructing the phototransistor remote enclosure.

ponent's delicate gates. Be sure to follow the directions that come with it.

Another critical component is capacitor C1, a special hermetically sealed subminiature component that is used in the circuit because of its low leakage and high reliability under nearly any conditions. Resistors R3, R4, and R5 have a tolerance of plus or minus 5 percent, again in the name of accuracy and reliability.

Phototransistor Q3 is mounted in its own enclosure, acting as a remote sensor for the meter circuit. Note that this is a transistor and not a photocell—it's somewhat more complex than the common photoelectric cell. It is best to use a transistor socket for the connections to the phototransistor. Any heat damage while soldering will thus be eliminated. The base lead is left disconnected and is merely bent off to the side. This arrangement is illustrated in Fig. 5-7B. The enclosure for the sensor need only be large enough to act as a stable support under your camera during the testing procedure. The photosensitive transistor will be located precisely in the center of the camera's focal plane, meaning that the sensitive surface of the cell will be best located somewhere near the center of the top panel of the sensor enclosure. Pad this top panel with felt to make it light-tight around the sides and nonabrasive to the camera back.

A good arrangement for the meter enclosure itself is shown in Fig. 5-7C. Most of the components can be conveniently mounted on a single piece of perforated circuit board. Switch S1 is a 2-pole, 5-position rotary type that is used to select speed ranges through different resistances. This switch also serves as an on-off control. A jack for receiving the leads and plug from the phototransistor and reset switch S2 are also mounted on the front panel. Potentiometers R6 and R9 do not need to be mounted externally since they are only adjusted initially to correlate the x1, x10, and x100 scales.

USING IT

A few preliminary tests are necessary before finally closing up the unit. With S1 in the off position, install the battery in the circuit. If the meter does not read zero, adjust the mechanical zero setting until it does. In the power position of S1, the meter should read exactly in the center of the scale. If it does not, make a slight adjustment with R12 until it does.

Plug in the phototransistor sensor and expose it to a strong light. Switch S1 can be in any of its three range positions. The meter should immediately indicate upscale. Pressing the reset switch should send it back to zero. Repeat this procedure

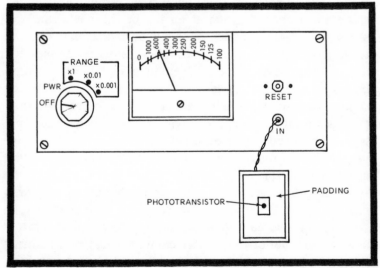

Fig. 5-7C. Completed shutter analyzer, showing the top of remote photo sensor.

HIGH INTENSITY LAMP

PHOTOTRANSISTOR SENSOR

TO METER-CIRCUIT ENCLOSURE

Fig. 5-7D. Using the shutter analyzer.

several times to verify the result. If the zero is off, adjust potentiometer R9 to correct it.

Carefully remove the meter cover and replace its regular scale with a blank for your own calibration. Obtain a camera that is known to operate reliably and use it for the initial control. Being sure its lens is wide open, remove or open the camera's back and center it on top of the phototransistor sensor (Fig. 5-7D). The sensor should be exactly in the middle of the camera's focal plane. Press the **reset** button and see that the meter returns to zero. Position a high-intensity lamp immediately above the lens. Set S1 at x1 and operate the shutter release. Mark the reading on your blank scale and proceed through other speeds covered in that range. The same is done for the other ranges. Discrepancies between the scales for the three different ranges can be corrected by adjusting potentiometer R6.

Remember to press the **reset** button after each measurement. When calibration has been completed to your satisfaction, you can appraise immediately and accurately how well the shutter on your own camera operates—whether it be under unusual temperature conditions or as a check on some unexplainably erratic photographic results.

PARTS LIST

B1 — 8.4V battery

C1 — 0.1 uF subminiature capacitor, hermetically sealed

J1, P1— Phono jack and plug

M1 — 0-1 mA dc milliammeter

Q1 — Motorola HEP 724 npn transistor

Q2 — RCA 40468A MOSFET

Q3 — 2N5777 phototransistor

R1, 10— 2.2K, ½-watt resistor

R2 — 100-ohm, ½-watt resistor

R3 — 220K, 1 percent precision resistor

R4 — 2.2M, 1 percent precision resistor

R5 — 22M, 1 percent precision resistor

R6 — 1K, linear-taper potentiometer

R7 — 680-ohm, ½-watt resistor

R8 — 200-ohm, ½-watt resistor

R9 — 500-ohm, linear-taper potentiometer

R11 — 2.7K, ½-watt resistor

R12 — 5K, linear-taper potentiometer

S1 — 2-pole, 5-position rotary switch

S2 — SPST pushbutton switch (normally open)

SONIC TRIGGER FOR ELECTRONIC FLASH

Question: what is the best way to catch a stop-action shot—besides the fairly obvious use of the electronic flash and the fastest lens that you have? Granted that a few photographers still regard the art as something akin to skeet shooting and seem satisfied with one hit—if not centered, at least on film—out of dozens of frustrated attempts. But who is going to be quick enough with either camera or flash to catch a balloon in the middle of bursting, a firecracker going off in midair, or an egg halfway through breaking on the floor?

The answer to freezing high-speed motion is to use a sensor that (1) is at least as fast as the motion itself, and (2) has the capability of firing a flash without having to rely on a very weak link in the chain—namely the human photographer. The device described in this project uses sound as its rapid sensor. Picked up through a microphone, the sound made by the event is amplified and used to trigger any ordinary electronic flash unit. Anything that makes a sound can be frozen in the nearly exact position in which the sound is made. The sonic trigger's sensitivity can be adjusted to allow for background or other extraneous noise.

HOW IT WORKS

The schematic for the sonic trigger is shown in Fig. 5-8A. The first part of the circuit is a basic audio amplifier formed by transistors Q1, Q2, and Q3. Input is from an ordinary high-output crystal microphone connected into the circuit through jack J1. The amplifier—direct-coupled and a far cry from high fidelity—feeds the amplified signal to the primary of transformer T1.

The voltage that appears in the secondary of T1 is split between resistor R2 and the gate of the silicon controlled

170

rectifier (SCR). In its normal condition, the SCR represents an extremely high resistance, simulating the open-circuit shutter contacts on the camera. The amplified signal from the microphone, however—when applied to the gate of SCR—causes the component's resistance to be momentarily reduced drastically, creating a closed circuit and triggering the charged flash. The SCR is on only as long as the sound has lasted, presenting no danger to the charging circuit in the electronic flash slave unit itself.

CONSTRUCTION

Component layout is not critical. Do watch the polarity of the SCR and the electrolytic capacitors in the amplifier circuit. Mount the transformer on the bottom of a moderately sized metal box. The other components can be supported and connected with the help of a multilug terminal strip.

Jacks J1 and J2, level-control potentiometer R1, and S1 are mounted on the top of the enclosure, as shown in Fig. 5-8B. Obtain an extra cord and connector of the type used between camera and flash. Cut off the end that would normally go to the camera. The two severed leads are then solder-tacked to a regular phono plug.

USING IT

With the microphone and flash connected to their appropriate jacks, turn S1 on. Be sure that the connections

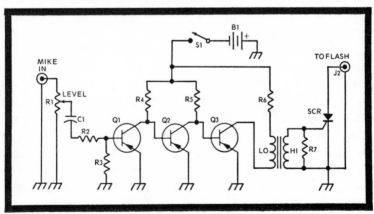

Fig. 5-8A. Sonic trigger.

Fig. 5-8B. Completed trigger with external connections to microphone and electronic flash.

between the flash unit and the sonic trigger are good, and that the flash unit is charged. Make a sound near the microphone, and at the same time gradually advance potentiometer R1 from a minimum setting to one at which the flash will fire.

If by some ill-fated circumstance the flash fails to fire—even at the maximum setting of R1 and with a thunderclap as the sound—the connections with which you could have made a mistake are very few. Check the SCR and see whether the strobe connection is wired accordingly to the schematic. Disconnect the wires from the flash unit from the phono plug and solder-tack them again—only this time in reverse. If the flash again fails to fire, check to see if there is an audio voltage across resistor R7. An affirmative reading could mean that the SCR is faulty. A negative reading will tell you to look over the amplifier wiring again.

Assuming that the unit is a success story, the next step is to set up for your high-speed action shot. A reasonably dark room will be necessary to avoid fogging or a superfluous background blur. Total darkness is not usually required, since the camera will be stopped down to an extent that will admit only the brightest image. Place the shutter-speed control in the **bulb** position and make the usual calculations with flash-to-subject distance—with the flash to be located near the camera—to determine aperture. If you are the owner of a single-lens reflex camera, you will be able to get some remarkable and dramatic results using a closeup lens.

With the sonic trigger connected as discussed earlier, place the microphone near the event, but outside the area that will be photographed. Simulate the sound of the event that you would like to have trigger the flash, and advance R3 only so far as is necessary to make the trigger sensitive to this particular sound level. Return R3 to its minimum setting again. We'll assume that the event to be photographed is a pin pricking a balloon. When you are ready to go, advance R3 to its predetermined setting, prick the balloon, close the camera shutter and the task is done. Don't forget to return R3 to a minimum again to forestall accidental flashing.

Careful positioning of the microphone provides an additional degree of control over what you actually expose. Every foot between the microphone and the event adds approximately 0.001 second to the time before which the trigger can activate. One foot can consequently make all the difference with something that happens as fast as the breaking of a balloon.

Although the sonic trigger is definitely an extra in the home photo studio, you will have many astounding and unique prints to show for the effort.

PARTS LIST

B1 — 9V battery
C1 — 0.022 uF disc capacitor
J1, 2 — Standard phono jacks
Q1, 2 — RCA SK3004, pnp transistors
Q3 — Motorola HEP 200 pnp transistor
R1 — 5M, linear-taper potentiometer
R2 — 200K, ½-watt resistor
R3 — 10K, ½-watt resistor
R4 — 22K, ½-watt resistor
R5 — 1.2K, ½-watt resistor
R6 — 27-ohm, ½-watt resistor
R7 — 470K, ½-watt resistor
SCR1— Motorola HEP 621
S1 — SPST switch
T1 — Audio transformer; 10K:4 ohms (Stancor A-3822)

AUDIO PHOTOMETER

The ears are more sensitive to changes in the pitch of sound than are the eyes to comparable changes in the intensity of light. If light intensity could somehow be transformed into corresponding audible frequencies, the ear might provide as reliable a guide to light intensity as the eye! Needless to say, the audio photometer does just that. An application for the device can be found in the darkroom as a continuously audible monitor of any light present in the area. It can be especially useful if you get absorbed in your work at the expense of knowing about any dangerous light levels that develop behind your back. You will be able to hear the slightest change in light intensity with the help of the audio photometer.

HOW IT WORKS

The schematic for the audio photometer is shown in Fig. 5-9A. The circuit is basically a light-sensitive oscillator whose frequency varies without the amount of light falling on the photovoltaic cell (PC). The device uses three grounded-emitter amplifier stages in the form of Q1, Q2, and Q3. These stages are connected in a positive feedback arrangement to accomplish the basic oscillator action.

The output of the Q2 stage is coupled to the base of Q3. It is also coupled back to the Q1 stage through capacitor C2. This feedback positively reinforces the frequency to which the oscillator is tuned. The only variable in the circuit—and therefore the frequency-determining factor—is PC. The photocell can alter the bias of the first amplifying stage, which forces the photometer's output frequency to a higher value. The use of three stages instead of two makes the oscillator more stable. Its output is coupled to an 8-ohm speaker through transformer T1.

CONSTRUCTION

The material of the enclosure does not matter as long as the positive terminal of the battery B1 is used as ground. Mount the solar cell (PC) under a small hole in the enclosure. If you expect to be handling the photometer roughly, a small transparent plastic window for the cell will help to prevent accidental damage. The overall size of the photometer needs to be no larger than that of a regular workhorse light meter. The use of a tiny speaker will increase the amplitude of the output. The unit is completely self-contained and can easily be carried in a shirt pocket. Figure 5-9B shows a convenient enclosure arrangement.

USING IT

Turn the power on with switch S1. After a slight delay, the photometer will emit a tone, dependent on the amount of light falling on the photocell. The lowest possible pitch of the meter will be with the photocell in a completely dark state.

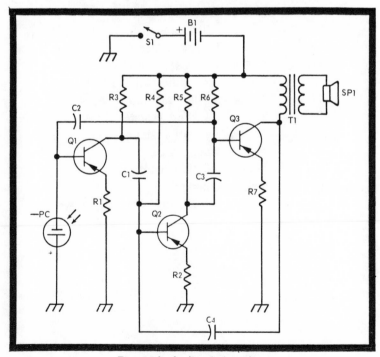

Fig. 5-9A. Audio photometer.

PC WINDOW

SMALL SPEAKER
MOUNTED BEHIND
HOLES

Fig. 5-9B. Completed audio
photometer; speaker mounted
behind perforations in enclosure.

At a given light intensity, compare the tone produced by
the photometer to a reading on a standard exposure meter.
Continue practicing with the two meters and before long you
will be able to judge available light accurately enough by ear
to take a good picture every time!

PARTS LIST

B1	— 9V battery
C1	— 0.02 uF disc capacitor
C2	— 0.12 uF, disc capacitor
C3	— 0.1 uF disc capacitor
C4	— 0.05 uF disc capacitor
PC	— B2M photovoltaic cell (solar battery)
Q1, 2, 3	— Motorola HEP 253 pnp transistors
R1	— 390-ohm, ½-watt resistor
R2, 7	— 47-ohm, ½-watt resistor
R3,5	— 10K, ½-watt resistor
R4, 6	— 100K, ½-watt resistor
SP1	— 8-ohm speaker
T1	— Output transformer (Stancor TA-43)

PHOTOGRAPHER'S TONAL TIMER

Whatever you say about all the other tellers of time—wristwatches, the blinkers, clickers, or the strong silent types—the simple **tonal** timer seems never to leave the picture. Since it uses only electronic components and does not have to resort to a mechanical relay to accomplish its periodic action, its operation is smooth and regular. The circuit's electrical output is transformed as perfectly as could be desired into the acoustic response of an ordinary 8-ohm loudspeaker. The result is a clear and sharp beep that can be adjusted for different tones and different rates of repetition. The output through a small speaker is audible, even with a moderate amount of extraneous noise in the area. Give the tonal timer a try and let its accuracy and usefulness—as they are reflected in one good print after another—earn it a place among the other old faithfuls. The fact that it makes you do a little work should not make it prohibitive.

HOW IT WORKS

The circuit (Fig. 5-10A) is an interesting combination of two different oscillators. Unijunction transistor Q1 and its associated components act as a relaxation oscillator, producing a pulse as frequently as the circuit's time characteristics permit. In this case, component values are selected to favor one pulse per second. This rate of oscillation is controlled over a limited range with potentiometer R2.

The second oscillator is formed by transistor Q2 and its related components. The positive feedback required to sustain oscillation is accomplished by the three separate resistor-capacitor networks that surround this transistor. Q2's output signal, by the time that it again reaches the input of the stage, has been turned around 180 degrees and is again in phase with

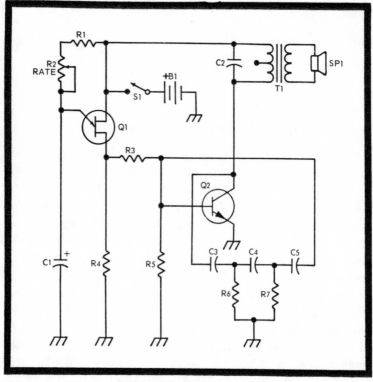

Fig. 5-10A. Tonal timer.

the input signal. The values of the resistors and capacitors determine the audio frequency at which the positive feedback is most strongly reinforced, focusing the circuit to a constant-frequency output.

The two oscillators work together—Q1 dictating the intervals at which Q2 will be kicked into a short-term oscillation. The oscillator produces a pleasant audio output in a small speaker that can easily be made to repeat precisely at one-second intervals with an unmistakable tone. Though not loud, it will keep you on your toes for the next one.

CONSTRUCTION

A universal meter enclosure will be the most convenient starting point for the construction of the tonal timer. The hole in the enclosure that normally accommodates a meter in this case will be just about perfect for mounting the speaker. (See

178

Fig. 5-10B. Use a universal meter enclosure to house the tonal timer.

SPEAKER

RATE OFF ON

Fig. 5-10B.) Be careful to leave yourself and the circuit enough elbow room in your chosen enclosure after the bulky speaker has been mounted in place.

Two multilug terminal strips will be sufficient to support and connect the majority of components. Other than this, the best layout policy will be to keep all connecting leads short and to the point and not try for the world's record in the cramped-quarters construction event. Whether you have accidentally introduced elements into the finicky audio circuit that will drastically affect circuit operation will not become apparent until the unit has been completed and turned on. If you double-check your wiring against the schematic and take the hint not to make a little snakepit out of your connections, there should be no problems.

USING IT

When the tonal timer is turned on, it will pause for about 10 seconds—the time needed to charge C1 in the unijunction oscillator circuit—then will begin emitting tones at a regular rate. Carefully adjust potentiometer R2 against the sweep **second** hand of an electric clock to calibrate the tones to 1-second intervals. Once this has been done, the tonal timer is ready for darkroom service. After a period of extensive use, or a long period of not using the unit at all, a slight adjustment of R2 may be necessary to bring the timing back into line. Additionally, as the battery ages it will also begin to lose its punch, affecting the frequencies of both oscillators. When no setting of R2 through its full range will produce that familiar 1-second pulse, it is time to invest in a new battery.

PARTS LIST

B1 — 9V battery
C1 — 100 uF, 25V electrolytic
C2 — 0.1 uF, disc capacitor
C3, 4, 5 — 0.047 uF disc capacitor
Q1 — 2N1671 unijunction transistor
Q2 — Motorola HEP 726 npn transistor
R1, 3 — 18K, ½-watt resistors
R2 — 10K, linear-taper potentiometer
R4, 6, 7 — 1K, ½-watt resistors
R5 — 12K, ½-watt resistor
S1 — SPST switch
SP1 — 8-ohm speaker (high efficiency)
T1 — Miniature output transformer (Stancor A8101)

LIGHT COMPARATOR

One of the essentials of your "integrated" nervous system is its ability to compensate and protect itself against extremes of perception in light, sound, touch, etc. The photographer's eye—usually to his great dismay—is a great "filler in" and "blocker out"—an adjuster according to mood of colors and intensities that his film, of course, is not able to imitate. Interpreting this sort of balance in the photographic scene is one of the photographer's most difficult tasks.

Although an ordinary light meter will give you virtually unerring accuracy in **average** or **spot** readings, it cannot provide similarly direct readings of contrast and comparison that often are more crucial than an overall decent average exposure. Even using two identical exposure meters simultaneously would leave you with the job of computing a guide number of one sort or another after taking the two readings.

One way to introduce a little "intelligence" into electronically isolated readings is with a photoelectric comparator. Two photoelectric sensors are balanced against each other to automatically give a direct meter reading of a contrast or comparative situation. In conjunction with an enlarger, after initial calibration of the comparator, readings are directly and immediately useful in selecting the correct paper contrast grade for the next exposure.

HOW IT WORKS

The circuit shown in Fig. 5-11A consists of two photoconductive cells wired into a balanced-bridge circuit configuration. Center-scale on the milliammeter represents identical light conditions for both sensors. This **zero-adjust** is accomplished in individual circuits with potentiometer R5,

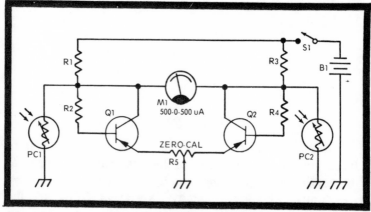

Fig. 5-11A. Light comparator.

given the initial test constant of equal light on both cells. For extreme precision, the two photocells must demonstrate identical light and frequency response. It is sometimes best to select the two cells out of several supposedly identical components to get the best match.

The circuit is designed to deflect a zero-centered meter in either direction, meaning that either photocell can register the greater intensity in relation to the other. Establishing one of the sensors as **dark** and the other as **light** makes it possible to instead use a full-scale, unidirectional meter, since all contrasts will cause a circuit imbalance in only one direction. Either method is entirely functional. The second will be suitable for metering a wider range, and thus greater contrast.

CONSTRUCTION

Two external, remote sensors and an enclosure large enough to house milliammeter M1 are the main considerations in constructing the photoelectric comparator. The most convenient enclosure is one designed to accommodate a meter movement. This universal meter enclosure also features precut holes for mounting the meter controls, which in this case is only potentiometer R5.

Two insulated-board or plastic sandwiches are ideal for supporting and protecting the remote photocell sensors. The light-sensitive surface of each cell is exposed through a hole of

Fig. 5-11B. Completed comparator using universal meter enclosure.

appropriate size in one side each of the insulating sandwiches. Photocell leads are then wired to phono plugs to meet corresponding jacks on the comparator-circuit enclosure. This arrangement is shown in Fig. 5-11B.

USING IT

Plug the sensors into their jacks, advance R5 to approximately midrange, and expose the photocells to light intensities you know to be identical. Turning switch S1 to its on position will probably caused the meter to deflect from zero, reading not an imbalance in the photocells, but rather an inappropriate setting of R5. Adjust R5 to zero the meter. Now the slightest differences between the resistances of the cells in response to different light intensities will cause the meter to deflect. Some trial and error with the comparator—perhaps using it in addition to your standard printing procedures—will enable you to use its readings directly in different photographic situations.

PARTS LIST

B1	— 4.5V battery
M1	— 500-0-500 dc microammeter
PC1, 2	— Clairex C1505L photoconductive cells
Q1, 2	— Motorola HEP 250 pnp transistors
R1, 3	— 690-ohm, ½-watt resistors
R2, 4	— 120K, ½-watt resistors
R5	— 5K, linear-taper potentiometer

ELECTRONIC FLASH

The advent of the electronic flash, or speedlight, has nothing less than revolutionized the photographic art. As commercial units become less expensive and their power supplies more compact, professional-quality work becomes possible for nearly anyone who is interested enough to acquire the equipment. The extraordinary speed of the electronic flash steadies even the shakiest camera hand. Action shots, or photos taken when the camera is accidentally jiggled, become crystal clear with the use of the speedlight; these are cases where an ordinary bulb flash would have turned the effort into a useless blur. The electronic flash is understandably compatible with much faster exposures.

Two main factors have made build-it-yourself electronic flash units impractical for the hobbyist. First, the cost of gathering the materials for a high-power flash and the time required for careful construction were not commensurate with the performance of the final product. Second, such a unit would tend to be unsafe. Less expensive, higher-quality components available currently at lower cost contest the first objection.

That homemade electronic flashes are unsafe depends entirely upon the skill, expertise, and care with which the construction of the unit is undertaken. The circuit described in this project should be undertaken only by the relatively advanced experimenter who knows his way around extremely high voltages.

The battery-powered electronic flash circuit in this project is a medium-power unit. The flash can be refired as quickly as its capacitor can recharge after a previous firing (approximately 12 seconds). Another advantage that goes along with the unit's simplicity is its low cost.

HOW IT WORKS

Circuit operation is very simple. Battery supply B1 (Fig. 5-12A) provides a steady 450V to the flash circuit. Capacitors C1 and C2 permit a much larger current drain during flashtube discharge than the battery alone could bear. C1 and C2 determine two things: the **brightness** and **duration** of the flash. The greater the capacitance in the circuit, the longer and brighter is the flash. For shorter duration, capacitance is decreased but the high dc voltage remains the same.

The high potential that is present across these capacitors goes to the flash circuit, where it readies V1 for firing. Capacitor C3 is charged through voltage dividers R2 and R3. Closing switch S1 on the flash unit (or via the sync connection of the camera shutter contacts) discharges C3 and generates a 6 kV pulse in trigger transformer T1. This pulse on the trigger electrode fires the flash tube. After a brief interval of recharging for the capacitors in the energy bank, the firing cycle is ready to be initiated again.

CONSTRUCTION

Extreme care in the construction of the flash unit and its battery supply is the main requisite. The source of any layout or operational difficulties that you could run into will boil down to four components—the large charging capacitors C1 and C2 in connection with the battery supply.

Leave nothing to chance. Use heavily insulated hookup wire for all of the flash unit's internal connections; and use

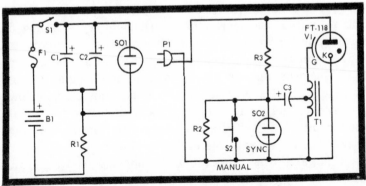

Fig. 5-12A. Electronic flash circuit. Note high-voltage power source connects to circuit via a plug-and-socket arrangement.

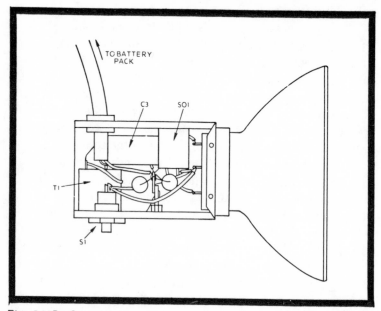

Fig. 5-12B. Circuit components may be conveniently mounted in an aluminum minibox chassis so long as parts placement doesn't deviate too much from the arrangment pictured here. The reflector is a standard item at most photo supply outlets.

heavy coiled cord between battery pack and flash, with a solid plug to the socket connection at the battery. It is best to avoid plug-and-socket on the flash head since the assembly will be handled frequently. Eliminate even the slimmest chance of an accidentally open power connection by running the cord through a hole in the flash-head enclosure wall and by holding it in place securely with a restraining clamp. Figure 5-12B illustrates the basic form that you should try to follow in construction of the flash circuit. The small box is aluminum; the aluminum reflector can be obtained from a local camera shop. Enclosure dimensions should be no smaller than 2 by 2½ by 2¾. With this size or larger, depending on your own preference, there will be enough room to safely mount and connect all of the flash-related components. Improvise a collar to hold the reflector to the circuit enclosure.

Final and foremost is the lead from trigger-transformer T1 to the trigger electrode of the tube socket. Use heavy coaxial cable or some similar substitute to adequately shield and insulate this connection.

Your battery pack hides a few pitfalls of its own. Probably the most convenient carrier for this part of the electronic flash is an ordinary camera equipment bag—it is cheap, easy, and insulated. Its worst quality could be that it might be a little flimsy for your taste, considering that at least one solid, high-voltage electrical connection will have to be made to the bag's contents.

The other good alternative is to use a closed metal box that is large enough to hold the two 225V batteries and the two large charging capacitors (C1 and C2). This method would provide a solid base for the plug from the flash head; it also makes it easier to secure the leads from batteries and capacitors (they carry voltage with a lethal potential). Either way, the physical arrangement of these main components of the battery supply should resemble the sketch of Fig. 5-12C.

Use a plastic or cardboard shield around the capacitors to further prevent accidental shock, as shown in Fig. 5-12D. Notice that resistors R1 has a 50W power rating. You will be able to better select other precautionary measures after you have gathered these components and seen their size relative to

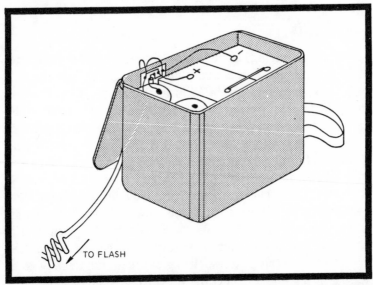

TO FLASH

Fig. 5-12C. The power-source portion of the circuit should be designed into a case that will minimize the likelihood of inadvertent electrical shocks. A coiled cord may be used to convey the high voltage from the battery pack to the electronic flash.

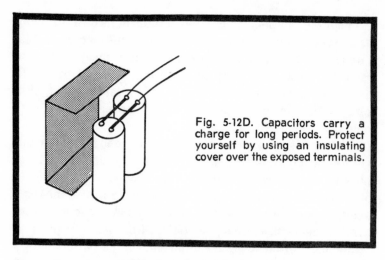

Fig. 5-12D. Capacitors carry a charge for long periods. Protect yourself by using an insulating cover over the exposed terminals.

the enclosure you'd like to use. You won't want to settle for anything less than the very best in self-protection.

Never assume that the charging capacitors are safe to touch. The only way to be absolutely sure that the capacitor terminals have lost their enormous potential, retained long after the supply has been turned off is to jumper the capacitor's terminals.

USING IT

When the wiring has been double-checked and is complete, close up both enclosures and plug the flash unit into the battery pack, making certain S1 is in the off position. For the initial tests, it is best not to connect the electronic flash to the camera, but instead use manual switch S2 to fire the flash tube. If there is an initial malfunction, there is no need to send its effects through the camera contacts. Face the reflector and tube away from you, turn on the battery pack, and depress S2 with one hand. The flash will fire, and immediately begin recharging. Ready time should be approximately 12 seconds. Once you are satisfied that your electronic flash works properly, fasten an aluminum strip to the bottom of the camera with a thumbscrew fitting to mount the flash head at the camera's side. Connect the PC cord, and the flash is ready for operation either manually or in sync with the shutter release.

PARTS LIST

B1 — Two 225V batteries

C1, 2 — 525 uF, 450V electrolytics

C3 — 0.25 uF, 400V tubular capacitor

F1 — Fuse, 0.25A, 3AG

P1 — 2-prong ac plug

R1 — 500-ohm, 50-watt resistor

R2 — 3.3M, ½-watt resistor

R3 — 4.7M, ½-watt resistor

S1 — SPST switch

S2 — SPST pushbutton switch, normally open

SO1, 2 — Chassis-mounting ac receptacle

T1 — Photoflash trigger coil (Stancor P-2426)

V1 — GE FT118 flash tube

Appendix

Experimenting with Photocells

In choosing a photocell, the applications for which the cell is to be used will determine which photocell parameters are of prime importance. For example, where the cell is to be used in a switching application, the greater the slope of the resistance characteristic (versus light level) the faster will be the switching action.

SELECTING PHOTOCELLS

Depending on the specific material which is used, the ratio of **dark** to **light** resistance tends to vary between cells from 100:1 to 10,000 to 1. In determining the resistance ratio it is necessary to specify at what time after the light is removed the **dark** resistance is measured.

A perfectly linear photoconductive material is one in which a given percentage change in light level will result in the same percentage change in resistance over the entire range of illumination.

In general, cadmium selenide (CdSe) cells are superlinear below 1 foot-candle and become sublinear above. All CdSe and cadmium sulfide (CdS) photoconductors become less linear as the light is increased; in the 10,000 foot-candle range they are almost asymptotic.

Linearity of resistance with changing light levels suggests a whole family of applications in the meter and control areas.

TEMPERATURE COEFFICIENTS

The temperature coefficients of photoconductors are rather unique, as they are a function of light as well as material. CdS cells have the lowest coefficient and in general their resistance changes inversely with temperature changes. CdSe cells have considerably higher coefficients and their resistance varies directly with temperature. As was stated

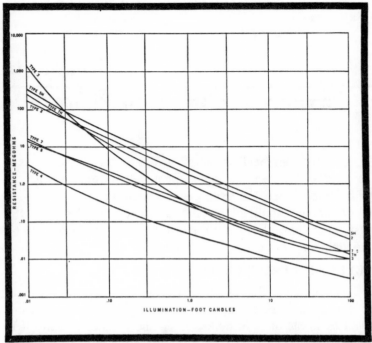

Fig. A1. Cell resistance curves for different materials.

earlier, the coefficient is also a function of light intensity. The coefficient varies as an inverse function of light level. Thus to minimize temperature problems, it is desirable to work the photocells at the highest light level practical.

PHOTOCELL RESISTANCE

The resistance of a photocell is a function of the basic material resistivity and total active area. In general, CdSe materials are considerably lower in resistance than CdS materials when used with conventional light sources. The second factor is the active area of the photoconductor, which is determined by the physical size and the electrode configuration. By today's evaporation techniques it is possible to deposit electrodes in very fine patterns which allow exposure of a large area of the cell surface and very close electrode gaps. This technique allows low resistance in small size cells; however, the close spacing requires lower voltage ratings. To obtain low resistance and high voltage ratings, it is

necessary to have a large photocell substrate with big electrode gaps.

In Fig. A1, the basic material resistivity curves are shown with the various factors for different electrode configurations.

SPEED OF RESPONSE

Speed of response of a photoconductive cell is the time required for the current to increase after the cell has been illuminated (rise time) and the time required for the current to decrease (resistance increase) after light has been removed (decay time). In general, turn on time is measured from the beginning of illumination to the time it takes the current to reach 63 percent of its final value. Response times improve with increased illumination, with CdSe cells being normally faster than CdS.

LIGHT HISTORY EFFECTS

In common with all known light sensors, photoconductors exhibit a phenomenon which has been called fatigue, hysteresis, light memory, light history effect, etc.

The phenomenon takes the following form: the present or instantaneous conductance of a cell at a specific light level is a function of the cell's previous exposure to light and of the duration of this exposure. The magnitude of the effect depends on the present light level, on the difference between present and previous light levels, and on the duration of previous and present exposures. The sense or direction of the effect depends on whether the previous level was higher or lower than the present one. (See Fig. A2.)

An example will help clarify this last statement. A cell kept at the test light level will attain an equilibrium conductance. If this cell is kept at a lower light level or in total darkness for some time and then checked at the test level; its conductance will be greater (than the equilibrium value) and will decay asymptotically to the equilibrium value.

Conversely, if the cell is kept at a higher light level and then checked at the test level, initial conductance will be lower and will rise asympototically to the equilibrium value. The higher the test level, the more rapid is the attainment of equilibrium.

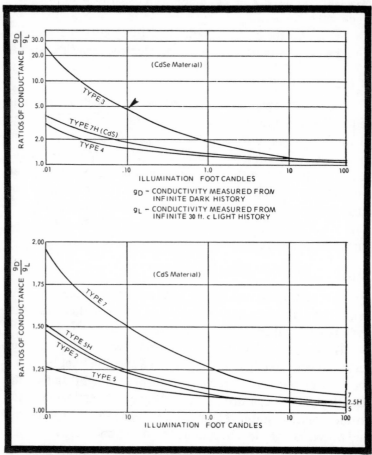

Fig. A2. Two graphs showing variation of conductance with light history.

The magnitude of the effect is larger for cadmium selenide than for cadmium sulfide; but the selenides tend to reach equilibrium more rapidly.

Naturally, this phenomenon must be taken into consideration in applying photoconductive cells.

The light history effect is a definite hindrance in the use of photoconductive cells for the measurement of light levels which may range in a random manner from darkness to very high light levels; precision is limited at any light level to the magnitude of the light history effect for that level.

For intermittent measurements, the effect of light history may be virtually eliminated by keeping the cell in a constant

light environment between measurements. For best results, a light level environment within the range of interest should be chosen.

PHOTOCELL SELECTION

Once the photoconductive material is chosen, it is then necessary to choose the appropriate physical package. In selecting a physical package the designer must take into consideration not only mechanical requirements but also the electrical ratings of the cell for appropriate circuit compatibility.

MAXIMUM CELL VOLTAGE

In specifying a photocell, care must be taken to insure that the voltage applied to the cell does not exceed the maximum allowable. Due to the fact that the maximum voltage is normally across the cell when it is in the dark, the voltage rating is measured with no illumination on the cell.

To properly select the best photocell for your application, it is important to understand the previous pages. Then examine the charts and graphs to pick out the photocell closest to your design requirements.

EXPERIMENTER'S CIRCUITS

The Schmitt trigger (Fig. A3) is a valuable control circuit that provides snap action control in which trip point and dif-

Fig. A3. Schmitt trigger.

R1 1KΩ	R5 680Ω	D1, D2 1N 536
R2 10KΩ	R6 270Ω	RY1, RY2 100Ω DC 2V
R3 470Ω	R7 270Ω	Q1, Q4 2N 1304
R4 680Ω	R8 1.2KΩ	Q2 Q3 2N 1305
	R9 1.2KΩ	PC CLAIREX PHOTOCELL
	R10 10Ω	TYPE CL 705HI

Fig. A4. Photoelectric servo.

ferential (hysteresis) are both adjustable independently of the relay characteristics.

Because of the trigger type switching, output transistor power dissipation is quite low even when considerable relay current is drawn.

1. Relay pulls in when cell is darkened

2. Relay pulls in when cell is illuminated

3. Both (or all) cells must be illuminated for relay to drop out (AND circuit)

4. Either (or any one) cell when illuminated will cause relay to drop out (OR circuit)

R1 sets operating point. R3 sets differential. The controls interact and adjustments should be alternated until both operating point and differential are within required limits.

Photoelectric Servo

Figure A4 shows a simple but accurate relay-servo for aperture or illumination control.

Fig. A5. Versatile photometer circuit.

Circuit drives cell resistance (illumination) to a value preset by R2. R10 controls dead band.

When level is correct, all four transistors are cut off. Power drain is limited to two relatively high resistance dividers permitting economical operation with dry cells.

Versatile Photometer Circuit

The amplified bridge-type circuit shown in Fig. A5 is adaptable to measurements over an extremely wide range of cell resistance (light levels), to narrow range comparison measurements (color balance) and to intensity ratio measurements (contrast).

Light levels of less than 0.01 foot-candle may be measured or compared.

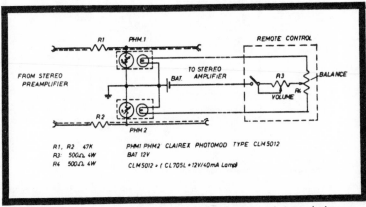

Fig. A6. Remote control unit for level adjustment and stereo balance.

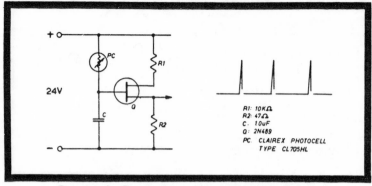

Fig. A7. A—D converter: light intensity to P.R.F.

Remote Stereo Level and Balance

This circuit (Fig. A6) requires no shielded wiring since the control leads are isolated from the audio circuits.

Control is smooth and noiseless. Control range is easily adequate for optimum personal adjustment almost anywhere in a room or hall.

Insertion loss need not exceed that required for balance.

Unit may be installed between preamplifier and power amplifier.

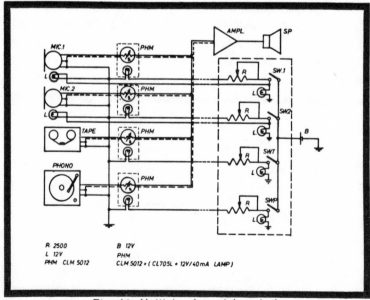

Fig. A8. Multiplex (remote) control.

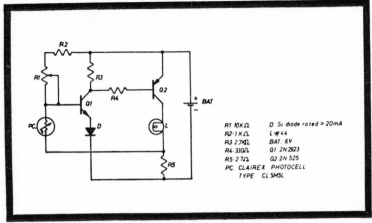

Fig. A9. Barrier lamp circuit.

Battery drain will not exceed 65 mA. A 6V hot-shot battery run 6 hours a day will serve for a month or more.

Flash-to-Pulse Converter

The output pulse frequency of the circuit shown in Fig. A7 is proportional to cell conductance, which follows the light intensity. The output is a series of voltage spikes that can be amplified and monitored via a small speaker.

Multiplex Remote Console

Switching, mixing, and level control in the circuit of Fig. A8 are all performed via isolated **cold** low-voltage dc lines.

Switching and level adjustments are clickless and noiseless.

A lamp at each mike indicates when the mike is live.

Barrier Lamp Circuit

The circuit shown in Fig. A9 is ideal for control of unattended lamps. Lamp goes on at dusk, off at dawn; day drain is less than one percent of night drain.

Low-power transistors can be used even for high-wattage lamps since circuit triggers output transistor from off to saturation, avoiding the high-current **linear** area of the characteristic curve.

Index

P

R

S